PHOTOGRAPHIC COMPOSITION
SIMPLIFIED

A MODERN PHOTOGUIDE

PHOTOGRAPHIC COMPOSITION
SIMPLIFIED

by

Paul Jonas

AMPHOTO
Garden City, New York 11530

Sixth Printing, January 1979
Library of Congress Catalog Number—75-34893
ISBN—0-8174-1149-6

Text printing and binding by Capital City Press, Montpelier, Vermont

CONTENTS

PREFACE

Unquestionably, photography is an art, and it has been accepted as an art by many museums in the United States and Europe for a long time.

However, only a small fraction of all the photographs taken at any time reach any sort of artistic level, just as only a small fraction of all paintings ever painted can be called works of art. The situation is the same in all branches of the arts. It is important to remember that a perfect ability to use the technical tools of an art form is not enough to make a person an artist; the speediest and most accurate typist is not necessarily a writer. And the finest writer doesn't even have to know how to type.

A photographer who claims to be an artist, though, must be a master of his tools, since most of his means of expression are bound to the technical performance possibilities of his tools, and he must have perfect knowledge of these. Knowing the capabilities of his tools allows the photographer to give order and purpose to his imagination and comprehension. All of this may be called photographic composition.

In this book, then, you will learn about photographic composition and how it is determined by a combination of technique and artistry. Once you learn and understand the rules, you will learn when the rules have to be maintained and when they may be stretched or broken to achieve results that may also be beautiful and artistic.

<div align="right">PAUL JONAS</div>

1

THE PSYCHOLOGICAL BASES OF COMPOSITION

HUMAN VISION VS. CAMERA VISION

Since photographers always try to arouse a certain illusion in the minds of their viewers, this illusion should match the inherent vision of the human eye. Otherwise, strange feelings may be aroused, and the goal may not be achieved. The only exceptions are abstract pictures, which have nothing to do with regular human vision; therefore, the viewer's illusion may extend beyond reality. The presentation of all other picture situations is based upon regular human vision, with all its mistakes, accommodations, transformations, inheritances, and dependence upon side effects.

In this way, the vision of the human eye is quite different from that of the eye of the camera; or, correctly speaking, the human mind accepts the outside world through the eyes in a way quite different from that in which film accepts the same world through the lens. The experienced photographer knows this difference and by using different means tries to project the image on the finished print according to the needs of human vision to achieve the desired illusion.

Composition is one of the most important means of achieving this goal. Since composition is an extremely flexible tool, one must know all its principles and their relationship to human nature in order to increase the efficiency of the tool and avoid its misuse. Therefore, we have to match the use of this tool to all the previously mentioned qualities of human vision. We have to compose our pictures in such a way that we take into account the psychology of vision.

These psychological facts are based upon inheritances and optical illusions. A few examples will draw attention to what we have to take into account while composing our pictures.

OPTICAL ILLUSIONS

In black-and-white photography the most important factor is the appearance of black, white, and gray areas in relation to their surroundings. The effect of the distribution of lines on the appearance of the picture area is also important. Both of these conditions are affected by optical illusions.

It is well known that a light area attracts the eye more than a dark area. It is not so well known, however, that a light area in dark surroundings seems larger than a dark area of the same size in light surroundings. See Diagram 1. The same phenomenon causes a white line in a dark background to seem thicker and longer than a black line of the same size in a light background. See Diagram 2. I can assure you that this phenomenon is not always caused by irradiation. According to our eyes, tonal qualities are also submitted to the law of relativity. The gray tone of the circles in Diagram 3 is the same in each box, but the darker the surroundings, the lighter it appears.

As noted above, light areas are eye-catching, and everything which is light seems closer to us. But, and this is a paradox, distant objects appear farther away when aerial haze intervenes, although haze makes them lighter. When the air is clear, the same objects seem closer to us, though

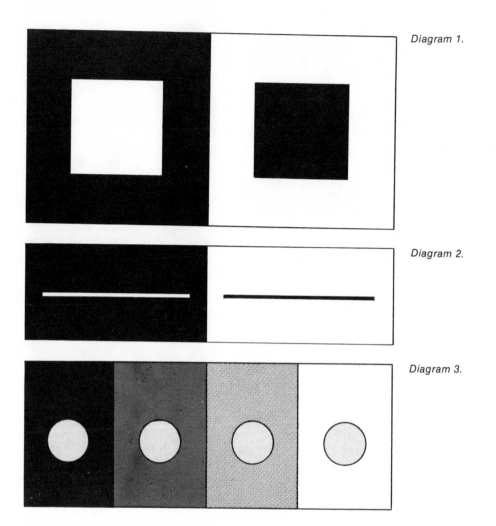

Diagram 1.

Diagram 2.

Diagram 3.

they appear darker than on a hazy day. This phenomenon is caused by an inheritance of human vision as it perceives distances in nature. The phenomenon manifests itself similarly in pictures.

If we go under the surface of consciousness, we discover that this phenomenon is really caused by the presence or lack of details. When the sky is clear, the recognizable details of distant objects make them seem closer. The suppression of details by aerial haze makes the same objects seem farther away. This also explains why light areas of a picture seem closer than dark ones: The eye, caught first by these light areas, recognizes their details, and is in-

clined to neglect the details of the dark areas. The paradox is resolved. Diagrams 4 and 5 demonstrate this inheritance in connection with aerial haze. In Diagram 4 the tonal qualities are presented according to nature, but in Diagram 5 they are reversed. Diagram 4 presents a correct illusion of distances, whereas Diagram 5 gives a strange illusion.

The effect of lines is submitted to optical illusion too. Diagram 6 shows how convergent lines may seemingly broaden an area. If the lines converge in the distance, they create an increased feeling of depth. Figure 1 presents this optical illusion in a photograph. The photograph is rectangular, and

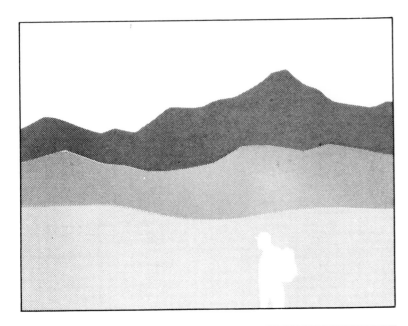

Diagram 4.

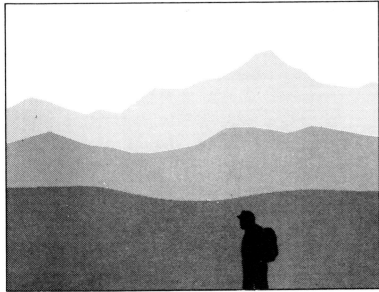

Diagram 5.

the illusion that it is not is caused by the converging railroad tracks, and not by a print trimmer. The appearance of the lines in this case is that usually produced by lines over an increasing distance. However, since there are many more lines in the background than in the foreground, this creates the impression that the top of the picture is wider than the bottom.

In the two-dimensional circumstances of photography, this phenomenon, created mainly by perspective, helps to create a three-dimensional effect.

WHAT IS PERSPECTIVE?

Simply, perspective is the geometric determination of that ability of human nature

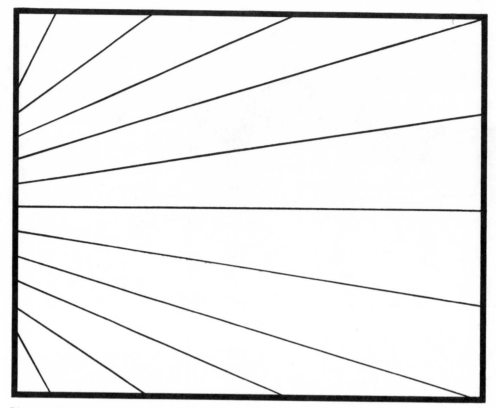

Diagram 6.

to feel the extension of things in the third dimension. This feeling is created primarily by our natural three-dimensional sight, but since photography is two-dimensional, we have to replace the missing advantage of binocular vision with certain photographic techniques. Perspective is the most important of these means.

Perspective feeling is created by the comparison of the apparent sizes of things, or parts of them, lying one behind the other, and is influenced by the distance from which we are looking at them. We may alter the relationship of distances between our viewing point and the front and back parts of the object or objects by moving. This changed relationship changes the appearance of the shape and size of the objects. This is the perspective effect.

On the other hand, since the actual size and extension of the objects have not been changed, the changed appearance works back in our mind and creates a feeling of changed distance from the entire object. As you will see in Chapter 4, the lack of an actual third dimension when we look at a picture gives us the advantage of playing with perspective at will.

(Right) A photographic example of the optical illusion, based on line effect, demonstrated in Diagram 6.

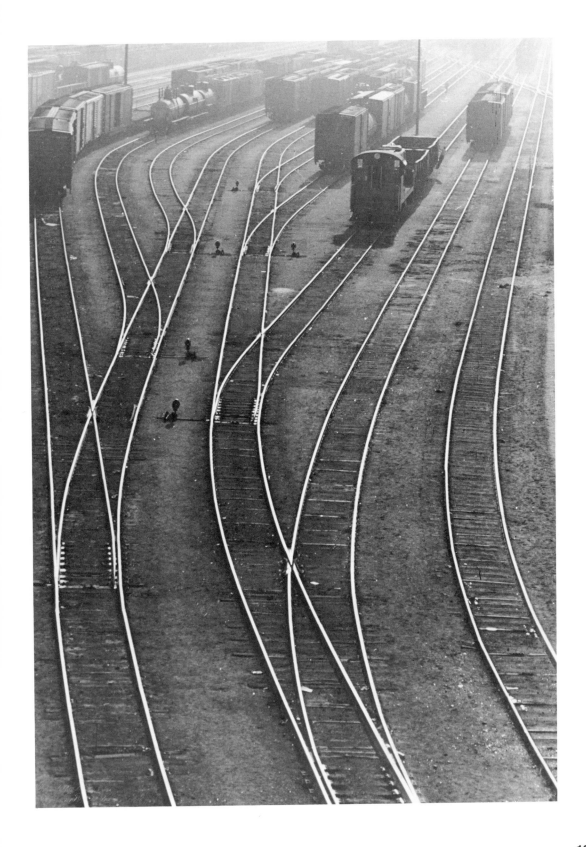

Since the human eye is pleased by perspective effects, modern architecture incorporates a number of them. Public places, especially exhibition halls, restaurants, and office buildings, are designed with frequent use of perspective effects. Sometimes in an ultra-modern building we cannot see two parallel straight lines; everything is subordinated to the designer's wish to create a pleasant illusion of roominess.

Perspective is utilized in stage scenery to give the illusion of extending the limited space. How much more important it is in motion pictures and in television. Similar techniques are used in studios.

Architects and designers use planned distortion to achieve perspective effects, but photographers—though they sometimes make use of this means consciously—sometimes have to struggle with the unplanned and unwanted distortion caused by their tools. I refer not only to the geometric distortion of lenses, but also to the distortion of tonal qualities, which plays an important role in the successful rendition of a scene or subject.

Since the human eye is not a perfect optical instrument, the brain has to correct its mistakes, and it does so very successfully. Unfortunately, we do not have such a built-in transforming instrument in our cameras, or anywhere else in the photographic process, despite the advance of automation. We must, then, take into account the lack of such an instrument and plan our pictures according to the needs of our other built-in instrument. If a correct rendition is desired, we have to take into account those transformations and accommodations which match our view to the image or illusion stored in our brain.

TRANSFORMING ACTION OF THE BRAIN

The most obvious and common example of this transforming action is the distortion of lines when the camera is not held level. Since the human eye is subject to the same optical laws as the camera lens, the image projected onto the light-sensitive layer of the eyeball is similarly distorted when we look up or down. But the brain corrects the distortion.

When we speak to someone face to face, our eyes do not show that person as having a big nose and small ears. A camera would, if we took a photograph from the same distance, even if the person really had a small nose and big ears. Again, the action of the brain transformed the distorted image of the human face into the image to which we are accustomed, an image independent of the distance from which we are looking at it.

When we watch a fast-moving object, say a racing car, it appears perfectly sharp, although a subconscious blurring occurs. If this subconscious blur were not present, we would have a strange feeling. To verify this I will use the example of a movie camera, which has variable exposure times (the shutter can be set for a fraction of the exposure time given by the frame speed, say 1/250 sec., instead of the regular 1/48 sec. at the 24-frames-per-second speed). When it is used with a much shorter exposure time than required by the frame speed in order to assure the sharpness of the individual frames, a strange illusion occurs. When the pictures are viewed, the movement does not seem to be continuous, but interrupted. But when the blurred images of the individual frames (the degree of the blur depends upon the speed of the subject) are transformed into a continuous movement during projection, our brain accepts the sequence of these images as sharp and quite natural. In the first case the movie camera worked against the transforming action of the brain, and the subconscious blur that occurs in our viewing system while watching movement was not taken into account. Although the circumstances and requirements of still photography are quite different from those of the movie, and sharp pictures are most often preferred (within the limits of regulated depth of field as a compositional means, as discussed in Chapter 4),

we can make use of this recognition of subconscious blur by skillful creation of blurred pictures to arouse an illusion of movement. The application of this technique is discussed in Chapter 6.

EYE ACCOMMODATION

I just mentioned the idea of regulated depth of field. The application of this technique is connected with another feature of the human viewing system—eye accommodation. One sort of accommodation is the ability of the eye to focus instantly on an object within the center of interest. This application of regulated depth of field seems very simple and obvious. But the situation is quite different from the premise developed, if one understands how this accommodation works. The human viewing habit, despite accommodation, recognizes the entire area first and focuses on the center of interest later. The image of the surroundings remains an exact memory in the mind. Since the camera does not have such a flexible feature, which yields a sharp and out-of-focus image of the same area at the same time, we have to take into account this difference between human comprehension and camera vision. Therefore, regulated depth of field is not a cure-all. It has to be supported by other means if we wish to maintain the illusion which we perceived visually.

On the other hand, the art of photography —like any other art—is not limited to the simple recording of reality. By changing the appearance of the factors of reality, it can achieve a specific effect. We can do this only when we know exactly how these factors will appear in the medium of photography. As we have seen, these factors appear quite different on film from the way we are accustomed, even without a planned change.

Another type of accommodation must also be considered. This is the accommodation to the color of the illumination, which will be discussed thoroughly in the chapter dealing with color photography. Here I speak only about its effect in connection with black-and-white photography. There is a contrast rendition in the negative other than the one expected, based upon a consideration of the contrast visible in nature. Since the eye of a semi-experienced black-and-white photographer judges the picture area in the gray scale (even the exposure meter does it in this way), he may not take into account the amount of colored light reflected into the shadow areas of the picture. We are accustomed to accept shadow areas as gray even if a lot of blue light is reflected there from a cloudless blue sky. Using a yellow filter in this situation without increasing the recommended exposure factor results in a serious underexposure of these shadow areas. The situation is similar in a green reflecting environment. The eye of the semi-experienced photographer accepts the flesh tones of his model as normal, even though a considerable amount of green light is reflected by a nearby bush. Since film does not accommodate itself, it records this reflection as underexposure, because its sensitivity to green is relatively less than its sensitivity to the other colors in the scene.

2

BASIC RULES OF COMPOSITION

In the previous chapter I examined the difference between human vision and camera vision. This difference makes it obvious that the rules of composition, and moreover any effort to gain effects, have to be applied in a way that takes into account the existence of a certain human viewing habit, and the inherited conditions connected with this habit. I have not yet discussed another great basic difference between these two kinds of vision: Human vision is unlimited in shape, but the vision of the camera is always limited to a geometric frame. For this reason, the camera's performance is limited. We can use our compositional means only within this limitation, and we have to utilize the possibilities of the available surface to maintain an illusion of the entire area in nature. More exactly, we must present an illusion to the viewer in such a way that he or she will not be aware of the limitations.

THE HORIZON LINE

At the outset of this examination, we must consider the arrangement of the picture into background, foreground, and main areas, and determine the relationship between these according to our needs. The placement of the real or imaginary horizon line is a very important factor, and if poorly placed, may reduce the effect of the picture to such a degree that it becomes worthless. In general, it is disadvantageous for the horizon line to be placed in the direct center of the photograph. It will divide the picture into two equal parts, which is dull. It is rather recommended to place the horizon higher or lower—into the so-called Golden Mean position or anywhere else between this Golden Mean line and the border of the picture. In most cases the low horizon emphasizes height, while the high horizon emphasizes depth and distance. Of course, the picture area may be cut below or above the horizon when special effect is needed, or for some other purpose.

THE GOLDEN MEAN

Before going on I would like to explain the meaning of the *Golden Mean*. This is one of the classic rules of composition. It was used by the great Greek sculptors as well as the great painters and architects of the Middle Ages. It is derived from the proportional construction of the human body in a relationship between parts of about $1/3$ to $2/3$. It means that when we divide some one or two-dimensional thing (line or area), we do it in such a way that the larger part is related to the smaller part as the whole is related to the larger part. (The approximate proportions are: 6.181 is to 3.819 as 10 is to 6.181, and from this comes the rough $2/3$ to $1/3$ relationship.)

The rectangular field of the photograph may also be divided by following the Golden Mean rule, and the elements of a picture set in such a way that they divide the field into a $1/3$ to $2/3$ relationship horizontally, vertically, or both. In the last case the intersection of the horizontal and vertical

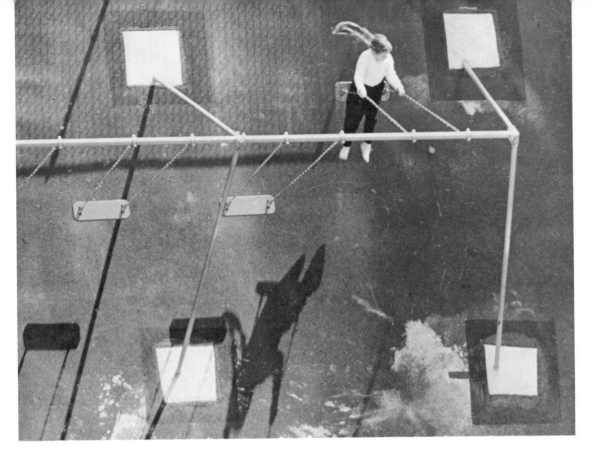

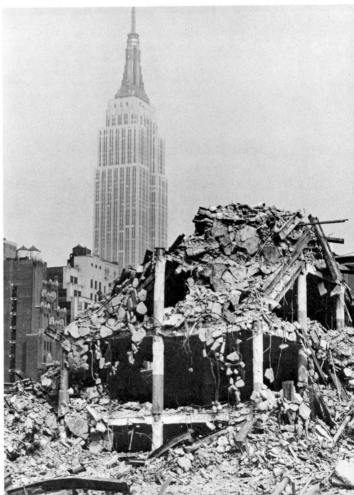

(Above) The white line of steel bar in the horizontal and the girl in the vertical Golden Mean line give a proper balance to the picture. (Right) The mass of the Empire State Building rising above the rubble in the Golden Mean line makes this photograph a properly composed one.

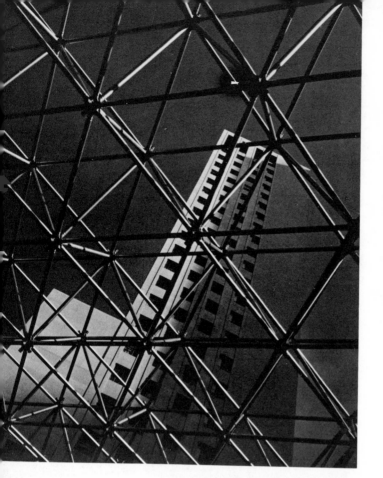

A medium red filter produced this sharp contrast between the sky and the metal framework. The construction of the picture is based upon line and pattern effects. However, without having first changed the tonal values, the effect would have been quite weak.

THE BEARERS OF THE CONSTRUCTION

The way we use or disregard the Golden Mean rule can be seen by the way we set lines and figures into the construction of the picture. Actually, lines and figures are independent compositional elements of the picture, and they determine the construction of the picture. By "lines" I don't necessarily mean real lines. A line effect may be created by placing figures along an imaginary path. As for "figures" I mean any kind of spot or surface in the picture area that has physical extension and definable contour. Both lines and figures may be light or dark. During composition we work with these light and dark elements, and our efforts are directed toward an arrangement of these elements in such a way that they determine, emphasize, or support the content of the photograph. These elements may also be used to catch the attention of the spectator just by creating a pleasant effect.

The way we fill up the rectangular area of the picture determines the construction of the composition. Because of possible pleasing or distracting effects, certain basic rules in addition to the more complicated effects I discussed in the previous chapter have to be maintained. There must be a relationship between the two, however.

BUILDING UP THE CONSTRUCTION

It is advantageous if compositional elements start to grow into the main area from the left bottom corner, since the eye is conditioned to move in this direction. Furthermore, if any moving subject or action occurs in a picture, it is desirable that the action is directed from the left to the right, either in a horizontal, diagonal, or an almost vertical direction. When the action, or the moving subject, enters the field of the picture at the left side, the exposure should be made as it approaches the center. Avoid shooting the picture after the subject has left the center and is going out of the frame. Many theatrical and movie directors have

Golden Mean lines (real or imaginary lines are present) is called the Golden Mean point. If we follow the Golden Mean rule, an agreeable and quiet view is presented to the viewer. I will examine thoroughly the psychological effect of the Golden Mean rule and the entire complex of symmetry and asymmetry in the next chapter. It is appropriate here, however, to mention that it seems to be advantageous to apply the rule when shooting quiet subjects, such as landscapes, still lifes, portraits, buildings, street scenes, and the like; but when the photograph presents movement, emotion, excitement, or action, the rule may be disregarded.

the leading characters step on stage or screen from the left side when they make their first appearance.

This relationship between the left and right sides of a picture has to be taken into account when we build up the construction. Thus, we should try to place the heart of the picture in the left side, if it is possible. If it is not, we should take care that compositional means (for instance, lines or the gaze of other persons in the picture) direct the attention of the viewer from the left to the right. If we cannot maintain this advantageous left-right relationship at the instant of exposure, we can still correct it during enlarging by reversing the negative. We can make this reversal, of course, only when no letters or numerals are obvious. Since human nature is highly susceptible to the un-

usual, the strange appearance of these letters or numbers would direct the attention of the viewers away from the main subject and towards the reversal. If a correct rendition is required—a portrait, or a picture taken in a well-known and easily recognizable place—we must not reverse the negative.

Beyond the maintenance of the proper left-right relationship, beyond the proper choice of relationship between the foreground and background, beyond the application or neglect of the Golden Mean rule, and beyond the occasionally symmetric or exaggeratedly asymmetric nature of the construction, the *balance* of the construction is an equally important factor, which necessarily involves all the factors thus far discussed.

This is what is called "the irregular repetition of figures." At the same time, there is a definite diagonal trend in the construction.

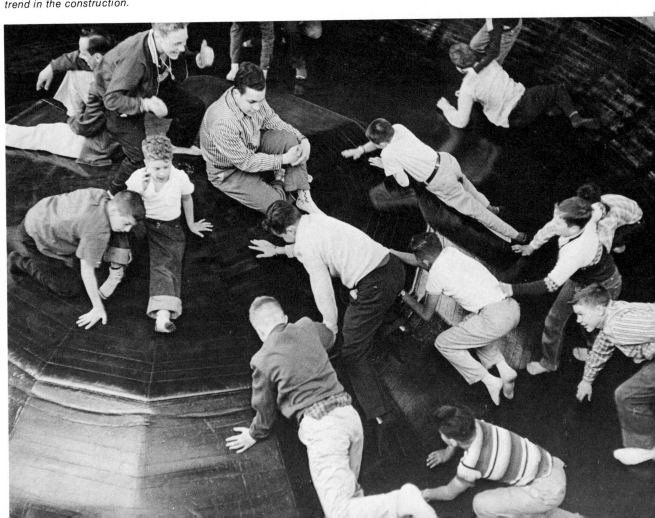

BALANCE

The balance of a picture is determined mainly by the distribution of the compositional figures, and other light or dark areas of the picture, which may attract the attention of the viewers. Since light areas attract the eye first, the position of these areas plays an exceedingly important role in the balance of the picture. In the most simple case, if only one light area is present in a picture (such as the face of a person), the Golden Mean point is most favorable. But it is important in which Golden Mean point the light area is placed.

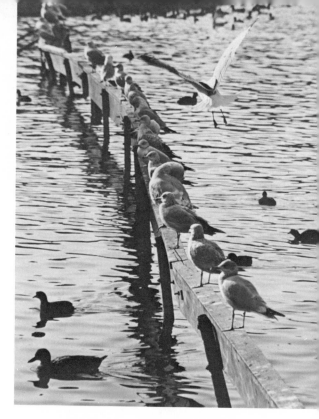

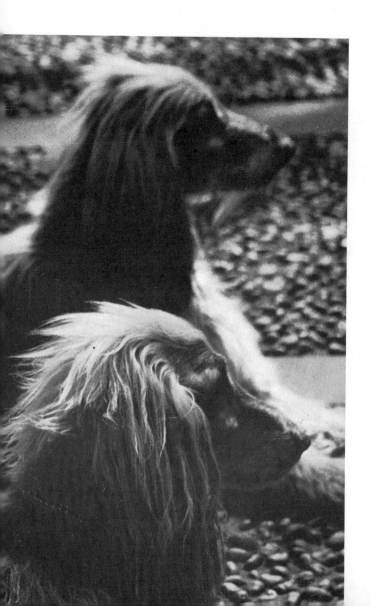

(Above) All the factors in this picture contribute to the feeling of depth: line effect, diminution effect, the seagull flying into the picture area, the gradually decreased sharpness toward the completely out-of-focus background. In enlarging, the negative was reversed so that the construction would begin in the lower left-hand corner. (Left) Regular repetition of figures. If the picture had been taken from a slightly lower angle, the head of the first dog would have covered the disturbing, strongly highlighted hair on the chest and paws of the second dog. Again, the negative was reversed in enlarging.

In general, the Golden Mean point chosen must allow a greater space on the side of the picture toward which the look of the person or the action is directed.

In a reverse situation, where the subject of a picture is dark and the surroundings are light, the same rules apply.

The situation is slightly more complicated if two main compositional elements or points of interest occur in a picture. If they are close enough to each other, they can be treated as one unit. If there is a greater distance between them, the tendency of the action has to be taken into

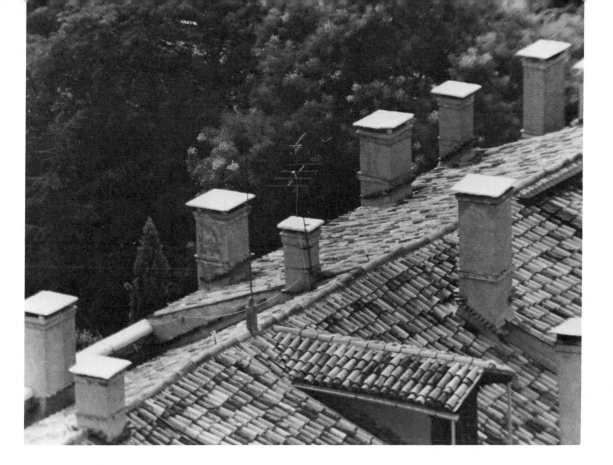

(Above) A basic example of simple diagonal composition. (Right) The skaters are placed along a diagonal line from lower left to upper right, and their postures introduce the effect of repetition.

consideration as well as the importance of the two elements (figures) in relationship to each other. The importance can be determined by the apparent size of the two figures and by the role they play in connection with the content of the photograph. In any case, it is favorable if these two figures are placed along the diagonal of the picture. If their action tends to move in the same direction, the secondary figure, which necessarily faces outward from the picture area, must be allowed a certain space between it and the frame. If the two figures are headed toward each other, the secondary figure

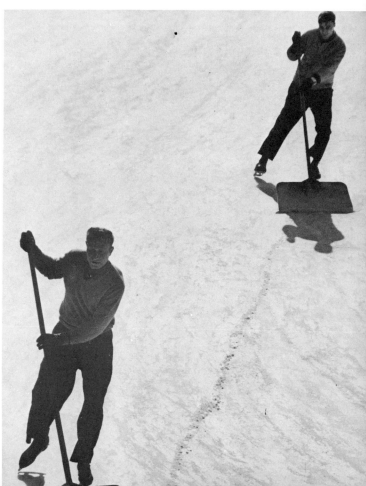

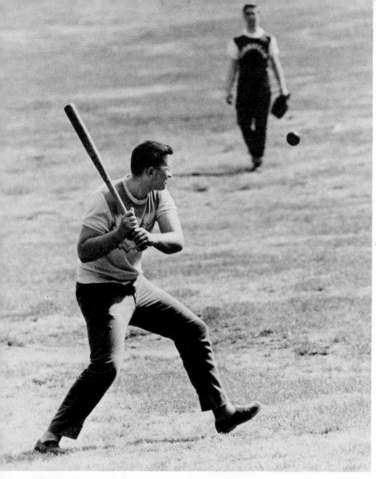

can be placed anywhere between the edge of the picture and the Golden Mean point. If it were placed closer to the center than to the Golden Mean point, an unbalanced space would be created behind it.

If more than two figures appear in the picture, they can be distributed into the nodes of an imaginary geometric figure or

(Left) The position of the two figures represents a diagonal composition. (Bottom left) The group of equestrians positioned in the Golden Mean line and riding along the diagonal of the picture made this photograph a properly composed one. (Below) This picture is based on a geometric effect produced by the shape of the parachute, its ribbing, and the lines of the tower and cables. The selection of the shooting angle, moment of exposure, and cropping in enlarging were determined to maintain a proper balance between the figure of the rider in his chair and the entire complicated structure of the parachute and its rigging.

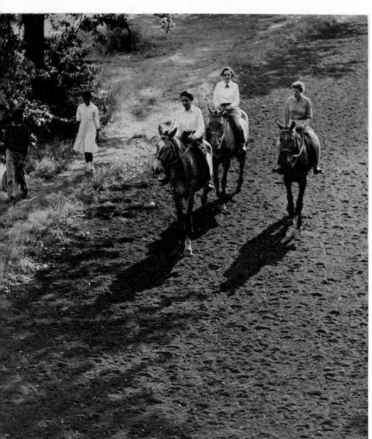

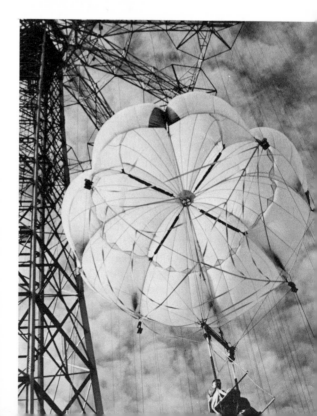

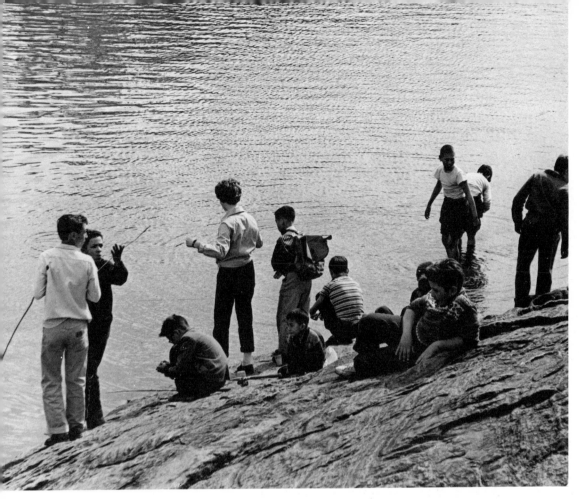

The lucky distribution of persons wearing light and dark clothing maintains a proper balance of tonal values. This feeling of balance is strengthened by the patterned appearance of the water serving as background for the "irregular repetition of figures."

along an imaginary line (either straight or curved). In most cases, one or two of them are accepted as main figures, and they should be treated according to the appropriate rules. Since their position in the picture area is easily determined, the placing of the other (supplementary) figures depends on extending the main figures into a geometric pattern. Supplementary figures do not necessarily have to be connected with the picture content. I will discuss this geometric aspect as well as other aspects of the distribution of figures and other compositional elements in the next chapter.

The existence of other types of compositional elements may greatly influence the balance of a picture. For instance, a patterned surface in an appropriate part of the picture area can restore balance to a picture which would be out of balance if a plain surface were used in the same area. Psychologically, the patterned area may replace a compositional figure. This is why it does not matter—as far as the balance of the picture is concerned—whether a cloud (compositional figure) or a pattern of branches covers the empty sky.

The light-dark relationship of the entire picture area often plays an important role in the balance of the picture. In general, it is preferable when the areas close to the edges are darker than the inside ones. The

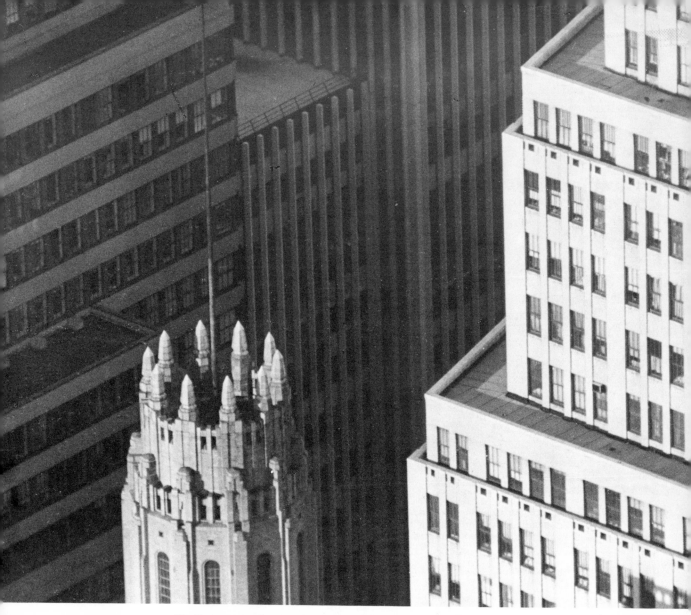

The tower protruding into the dark area of the picture serves as a counterbalance for the light mass of the building at right.

great Dutch painter Rembrandt accentuated the principal content of his paintings by keeping it light, while the surroundings —which were less important—were dark. This "Rembrandt effect" can be applied very well in photography, without your being accused of stealing a means from another visual art, for any light effect is photography's own.

What I discuss in the foregoing is only the acknowledged basis of photographic com-position, and it does not mean that the reader cannot use his or her own solutions, depending upon the situations and requirements. But it is always good to keep these bases in mind in order to consider the expected effect of a deviation from the bases.

Remember: Composition is not a rigid, but a very flexible and rich, tool of picture making. But we have to use self-control in using this flexibility, just as we have to strive to avoid rigidity.

3

CONSTRUCTION IN COMPOSITION

LINES

Lines are almost always present in a photograph, just as they are in nature. How to use these lines is a matter of the compositional ability and knowledge of the photographer. It is not essential to give an apparent line effect to every picture. Line effects may be hidden, but an efficient analysis of the photograph may bring them to light.

There are many purposes for the photographer's use of line effect, but one stands out above all the others: to lead the viewer's attention to the main subject or situation. Besides this main purpose, lines may produce, solely by their appearance, a pleasing or decorative effect, or they may emphasize perspective or depth. We may also set the subject or subjects along some real or imaginary line, sometimes using hidden line effects for this purpose.

Because lines may be vertical, horizontal, diagonal, or curved, there are almost innumerable possibilities for showing line effects. I shall try to analyze and examine the kind of response that may be aroused in the mind of the viewer by various line settings. I shall start with disadvantageous ones.

First, it is definitely wrong for a line to cut the picture in the middle, either horizontally or vertically. If we cannot avoid lines running parallel with the edge of the picture—as is often the case with trees, buildings, and with the horizon itself—we should try to set them so they divide the picture area unevenly. The most favorable position for these lines is the Golden Mean position, where they divide the picture into two areas (or perhaps four) with a ratio of about ⅓ to ⅔. In any case, lines running parallel with the edge of the picture may give a dull feeling to the spectator, and symbolize flatness. An exception is when the lines produce a natural frame for the picture area (as in the case of a window), or when they are employed to produce a pattern effect instead of line effect. The best example of this is a forest, where several vertical lines running parallel with the edge of the picture produce a pattern and cannot be called line effect.

Diagonal lines make a more dramatic and pleasing effect for the viewer and are often connected with the efforts of the photographer to emphasize the third dimension. In most cases, a diagonal setting of lines is most favorable. Convergent lines show a diagonal trend, and they are most useful means to produce the illusion of depth. When one of the main lines starts in the foreground, the most favorable starting point is the left-hand corner, because it leads the eye in the direction that matches the reading habit.

FIGURES

By figures I do not necessarily mean the subjects of the picture. I refer to those compositional elements that fill out the picture area or some part of it. The construction of the picture is based upon the presence of such figures. By their appearance and shape, and by their distribution in the picture, they produce different effects. They may be dark or light and of any shape; they

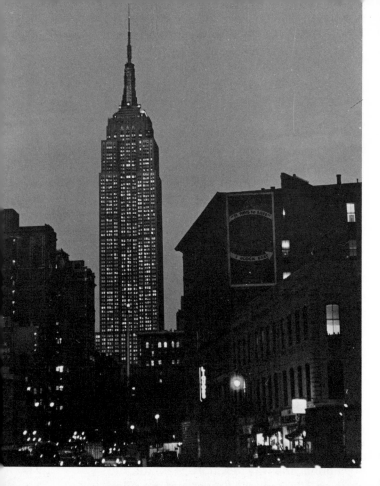
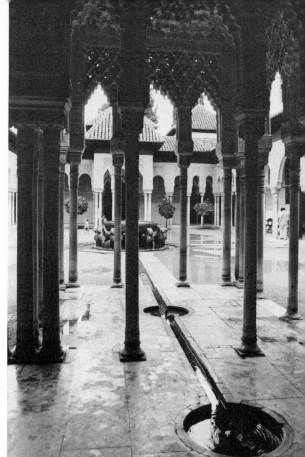
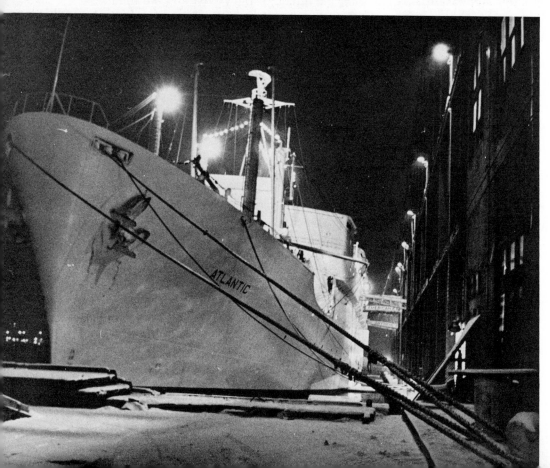

(Far left) It is proper to position the subject in the Golden Mean line. (Left) The narrow canal leading from the little fountain toward the main picture area breaks up the somewhat monotonous effect of the vertical columns. (Below left) The cable running diagonally holds together not only the ship but also the picture (compositionally). (Right) The repetition of identical and nearly identical shapes and lines represents a strong pattern effect. Though two rows of balconies run diagonally through the picture, a diagonal composition is not introduced; they merely break up the monotony of the parallel lines. (Below) A clear example of diagonal composition.

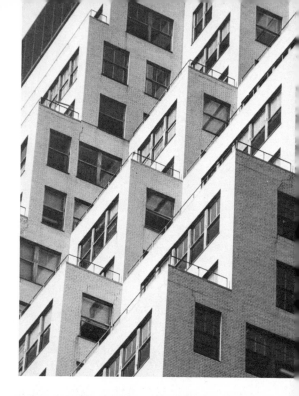

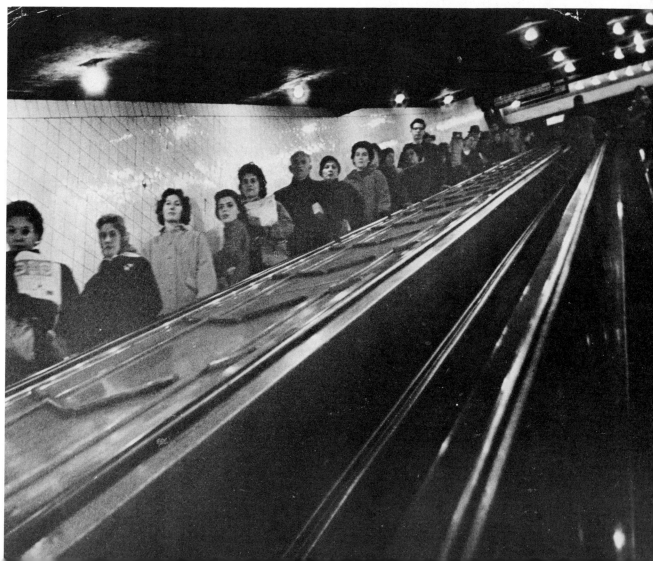

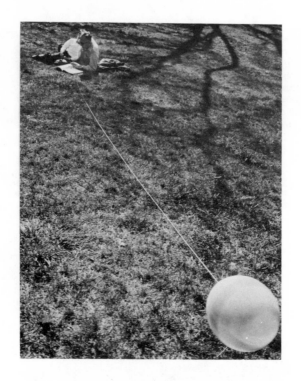

may be shaped so that it becomes a compositional figure. It is very advantageous when the subject serves as a device of the composition. This simplifies the entire construction of the photograph, and the simpler the construction is, the greater the effect that may be achieved. It is a general rule that confused composition produces confused effects in the mind of the viewer.

(Left) A strong example of diagonal composition. (Below) The diagonal setting of lines, together with the perspective diminution of figures, gives a feeling of distance, and the rhythmical repetition of postures creates a strong impact. Since the firemen are in a balance exercise, the balance of the picture must be no less perfect than theirs. Therefore, the picture was cropped (and the light area of the wall at the right was burned in) so that the dark area of the window was placed as close as possible to the upper right-hand corner to serve as counterweight to the heavy and almost empty dark area at the lower left.

may show similarity to each other, or they may achieve the desired effect by contrast. They may be evenly distributed in the picture area, producing a rhythmical effect, or they may be unevenly distributed and still produce a kind of rhythmical effect by the pattern of their repetition. This is called the *rhythmical repetition of figures,* and is used mostly to achieve depth effects, especially when diminution of the figures is involved. The opposite of this technique is called *irregular repetition of figures,* which is used to produce or emphasize excitement, movement, change; in a word, imbalance. Figures may be set along some real or imaginary line or in some geometric pattern.

Combined in this way with other kinds of effects, they form elements of the picture construction. A combination of two or more compositional means usually strengthens the effect, especially when this combination is simple and easily perceived. The subject, or a certain part or parts of the subject,

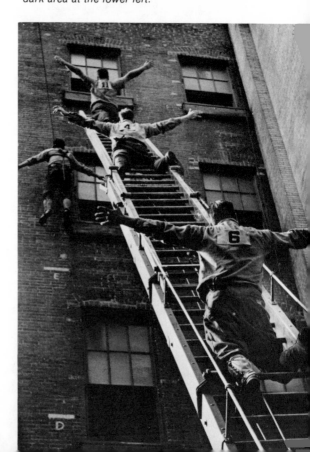

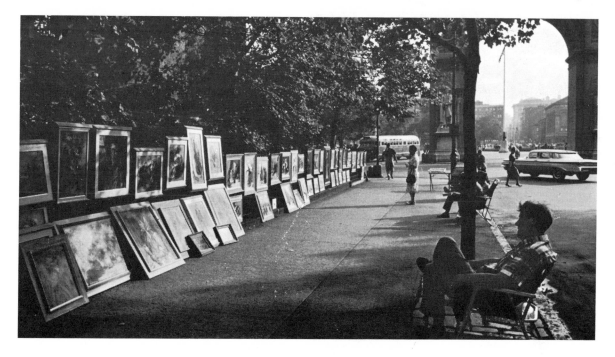

Some of the ingredients of depth composition are recognizable here: line, figure, and haze effect. At the same time, the picture shows a triangular composition.

PATTERNS

Since human nature is susceptible to geometric figures, patterns, which appear as a kind of geometric construction, are very attractive devices. Informal patterns may be used to break the flatness and dullness of the background and foreground. Patterns may produce a line or figure effect, or perhaps the entire construction of the picture will be based upon pattern effect. Because of the human susceptibility to geometric figures, everything around us is categorized according to geometry, so it is not very difficult to discover these figures and use them for our purposes. Geometric patterns may be produced in the photographic composition as a form of figure effect; i.e., the regular repetition of figures. Whether it is called "figure effect" or "pattern effect," it is, nonetheless, based upon our geometric susceptibility.

Not every geometric effect may be called a pattern effect. When we arrange the figures of a photograph into the vertices of a triangle, this is definitely a geometric effect, but not a pattern effect. In a photograph of a person walking down a stairway, the

sual arts, although occasionally extraordinary effects may be achieved through a strictly symmetrical arrangement. The statement that symmetry is unwanted may seem contradictory to the susceptibility of the human eye to geometric arrangements. But whether these arrangements are symmetrical or not, we see them in the perspective natural to three dimensions. This is so in the photograph as well as in nature: Really symmetrical arrangements projected onto a perspective plane lose their original symmetry. If they did not, we would not have an illusion of three dimensions.

Since photography usually tries to present pictures in accordance with the realities of human vision, the lack of symmetry in even the most symmetrical presentations

stairs don't represent a geometric or line effect, but a definite pattern effect.

Geometric and pattern effects usually are hidden in the construction of the picture. This means that important elements of the composition are arranged into the nodes of an imaginary geometric figure. Actually, the geometric effect is a manifestation of the figure effect.

Summing up: Two kinds of pattern effect exist. The informal, in which the pattern is used as decoration; and the geometric, in which the arrangement of figures in the construction shows a geometric distribution.

Geometric effects lead us to a discussion of *symmetry* and *asymmetry* in photographic composition.

SYMMETRY AND ASYMMETRY

In general, symmetry is unwanted in photographic composition, as in the other vi-

(Left) A basic example of simple irregular pattern effect. (Below) The pattern of the steel supporting bars of the dome serves as a compositional structure for the picture.

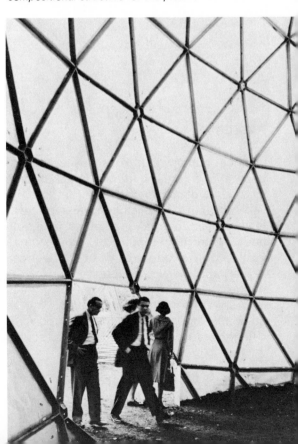

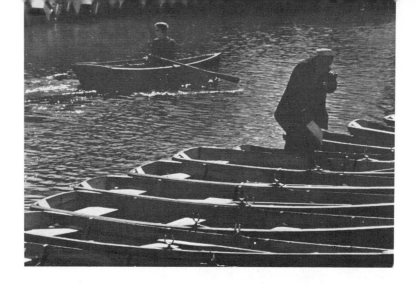

(Above) Backlighting increases the three-dimensional feeling built up by other means, such as figure effect and the decreased sharpness toward the background. (Below) Light accentuates all the compositional means used in this picture. The sharp backlighting infuses life into the sprinkling water, producing a line effect, or more exactly, a pattern effect. The strong lines of the stairs and the two circles in the lower right corner (the head of the boy and the balloon), from which point all the lines extend into the picture area, were also accented by light.

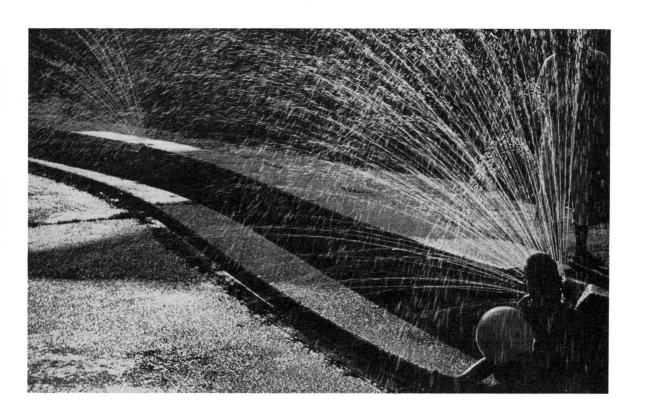

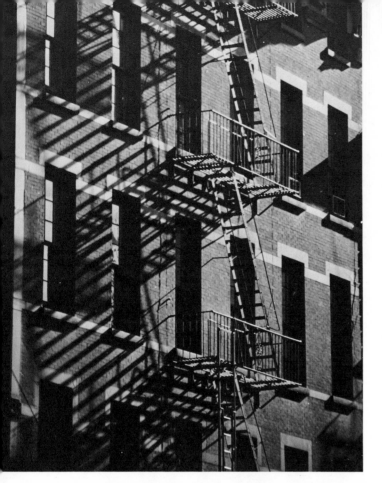

corresponds to human vision. We say "usually" because there are abstractions in photography that do not represent human vision, though deviations from the rule do not necessarily imply abstractions.

Thus, when asymmetry is used in picture composition, it takes advantage of the human attraction to asymmetry. The most obvious demonstration of asymmetric composition is the Golden Mean rule. The application of this rule gives a comfortable feeling to the viewer. Sometimes this feeling of comfort is so great that it does not draw particular attention to the picture, so in certain cases we disregard the Golden Mean rule and by exaggerated asymmetry give the picture more dramatic composition.

(Left) The shadows of the fire escape made photographing this particular segment of the building worthwhile. (Below) The little Spanish village on the mountainside created a good opportunity to capture an irregular pattern effect.

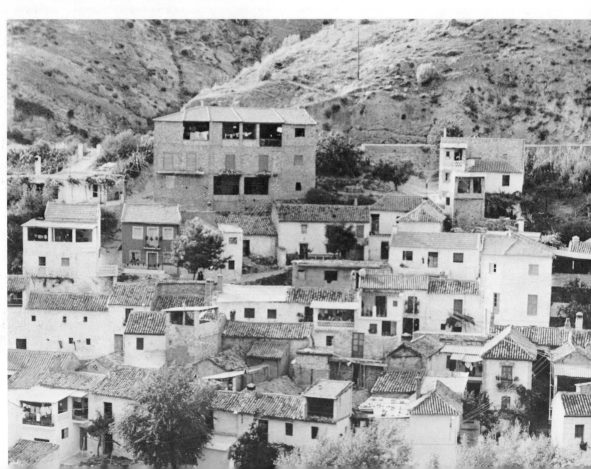

When to use this exaggerated asymmetry depends on the situation and on what we wish to emphasize. When the picture must show action, movement, emotion, excitement, or large space, we may use this exaggeration. But when the picture is of quiet subjects and objects, such as still lifes, portraits, street scenes, buildings, or landscapes, the application of the Golden Mean rule is advantageous.

Because no rule is without exception, especially in aesthetics, we may use the Golden Mean rule in the first type of pictures and disregard it in the second. Further, we may use exaggerated symmetrical composition in our pictures to arouse attention, since it is not the normal way of seeing things and therefore may give rise to stunning results, because the unusual catches the eye more quickly than the usual. Conscious adaptation of the trick

In these two pictures, the lines do not represent a line effect, but a definite pattern effect. In the photograph where the line of the steps runs parallel to the edge of the picture (considered disadvantageous in composition), no decreased attractiveness can be observed.

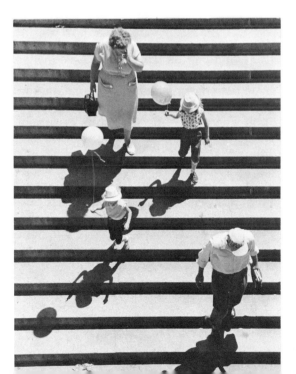

may arouse attention, but, again, how and when to use it depend on the photographer's taste and imagination, and, of course, the situation.

CONTRAST AND SIMILARITY

To make best use of the unusual it is important to take advantage of the contrast effect. Properly speaking, the kind of contrast effect I will discuss here does not belong, in the strictest sense, among the technical means of composition. It is, rather, an intellectual means. The technical contrast effect will be discussed in Chapter 5, in which I will talk about light effects.

The subject of our picture may be strongly emphasized when we incorporate in the same picture the opposite of what we would like to show. This may also give the picture a humorous accent. For instance, if we take a picture of a very tall man, his height is accentuated when he is walking with a small child (this case is not humor-

33

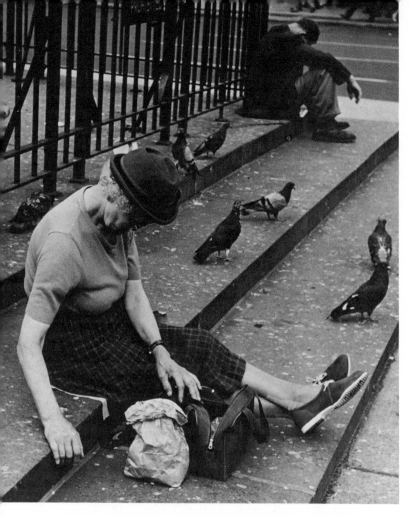

This photograph is a prototype of depth composition. It is based upon the perspective diminution of two figures holding the same altitude and set along diagonal lines.

ous) or when he is dancing with a very short woman (this may be a humorous case). The contrast effect is often used in advertising photography; for instance, when a late model car is shown with an old-fashioned one, or when a particular brand of whiskey is placed in surroundings that simulate the desert. The contrast effect appeals to the viewer's comparative sense to achieve its advantageous emphasis.

On the other hand, contrast effect may ruin our efforts if it is used improperly, without moderation or consideration. For example, a beautiful woman would not appear more beautiful if she were photographed in ugly surroundings just for the sake of contrast. This picture might arouse disgust rather than increase the feeling of beauty.

The similarity effect appears to be the opposite of the contrast effect. Actually,

they are close relatives. The beautiful woman whom we photographed amid ugly surroundings really deserves a gorgeous environment. In a purely technical meaning, similarly shaped figures appearing repeatedly in the same picture area can strengthen the effect of the main situation. The effect can be strengthened also when more than one person or group perform the same action or maintain the same attitude. On the other hand, there might be situations where secondary persons or groups are performing different actions or holding different attitudes than that of the main person or group. This may be utilized to implement the contrast effect. Since there are almost innumerable possibilities to use contrast and similarity effect in picture composition, it is good to keep them in mind and be ready to use them when the opportunity arises. They are very valuable tools.

4

THE THIRD DIMENSION
IN COMPOSITION

THE ILLUSION OF DEPTH

Photographers are often disappointed when they see the results of their picture-taking and discover that what they saw in the finder at the instant of exposure was an image quite different from the one on their print. This is not surprising to experienced photographers, who know that we see a scene in nature in three dimensions, and that the image of the same scene is reduced in a print to two dimensions. In this process a great part of what we found attractive is lost.

In order to maintain a natural three-dimensional effect in the print, certain rules have to be applied. Although many scenes lend themselves well to two-dimensional renditions, it is always profitable to keep in mind those procedures which may give more impact to the picture by producing the illusion of depth. Besides, there are lots of scenes which may be made to appear three-dimensional through the medium of photography only if we apply those rules which produce an illusion of depth. In photography, as in other two-dimensional art forms, this procedure is called *depth composition.*

There are four main means available for achieving depth composition, which creates an illusion of a difference of distances. These means are regular constructional elements of photography. I discussed them in the previous chapter and now I would like to study them from the standpoint of depth composition. These means are: *Line effect; Figure effect; Light effect; and Haze effect.*

These effects are usually combined to produce a successful picture. They are often not apparent, yet we can evaluate a picture in terms of these effects so as to show the skeleton of that picture. Now, let us see how to use these effects to create the illusion of depth on a two-dimensional surface.

Lines

In nature there are several lines or line-like formations which may be used for our purposes. If we find them—either open or hidden—we can build them into our picture composition in such a way that they direct our eyes toward the depth of the picture area. This means that we should try to find a camera vantage point that insures that these lines or line-like formations start in the foreground and continue toward the background. In this way we get some kind of scale for the distances incorporated into the picture. With this scale we have also increased the illusion of depth in the picture. When two or more lines are directed toward the background, they obviously tend to converge, so that in addition to the scale effect, they create a perspective effect also, which increases our illusion of depth.

Figures

When similarly shaped figures or patterns are placed one behind the other, or when subjects of well-known size are distributed into the depth of the picture area, the perspective diminution of these figures or patterns creates a strong feeling of distance-differences. This feeling is increased if

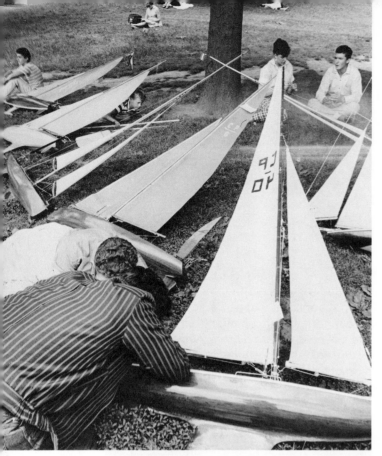

these figures appear rhythmical (in the form of regular repetition) or if they are set along some kind of imaginary line, also creating in this way a hidden line effect.

Light effect

Actually, this effect comes into existence in the form of lines and figures, so it cannot be separated from the previous effects. Both the lines and the figures in a scene are created or accentuated solely by the light, but since light is the most important element in photography, it should be treated as an equally important effect. For instance, when the shadows of trees are running to-

(Left) The triangular composition, creating a feeling of depth, is easily recognizable in this picture. (Below) The diminution of similarly shaped figures represents an important factor in depth composition.

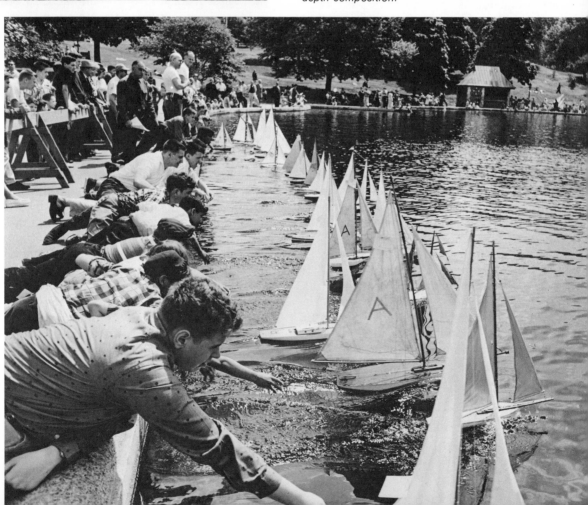

ward the camera, a line effect is created solely by the illumination of the scene. When the contours of the figures of a scene are illuminated by strong side- or backlight, the figure effect is tremendously increased. And it is well known that backlighting is a very effective means of creating a three-dimensional effect—but I do not want to get ahead of myself. I will discuss this in the next chapter.

Haze effect

It is a psychological fact that distant objects in a scene which are not readily recognizable tend to appear even more distant. Aerial haze, which diffuses distant objects, produces this effect, which is heightened if the foreground is distinct and strongly emphasized. Regulated depth of field, in which the more distant areas are purposely thrown out of focus, belongs to this group, since the psychological effect (the illusion of distance) of unrecognizable or less recognizable details of unsharp objects is similar to that yielded by haze. Regulated depth of field is a very important means of photographic composition and rendition, and I shall discuss it more extensively.

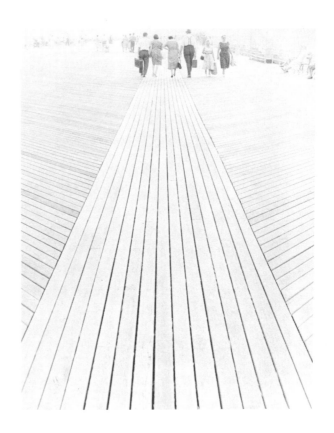

(Above right) A strong example of triangular composition. (Below) This is an example of how light alone, in the form of shadows, can provide the construction of a picture.

DEPTH OF FIELD

Literally, *depth of field* means the zone of sharpness of a picture area yielded by the camera's lens. Technically, the depth of field is determined by *circles of confusion*. These circles of confusion are image points projected onto the film, since points are always seen as smaller or larger circles. When these circles are not larger than the accepted standard, we call the image sharp. These smaller or larger circles come into being in this manner: Light is focused by a lens in the form of cones, with the image sharpest at the tip of the cone. Only a point at the focused distances lies at this tip and on the focal plane. The tips of the cones not at the focused distance are in front of or behind the focal plane, which intersects these cones. If the diameter of these intersected cones is smaller than the accepted standard of sharpness, then we

37

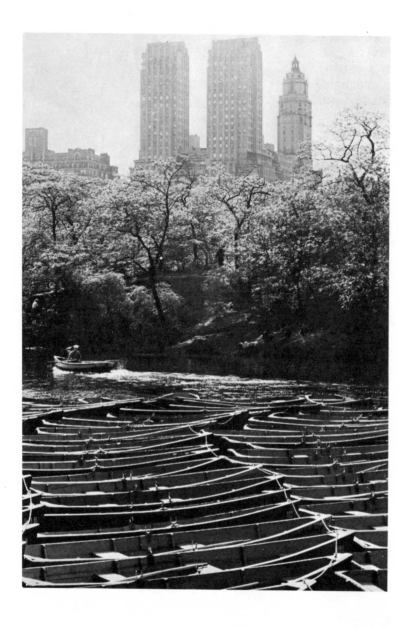

accept the image as sharp. As I said, the tips of these intersected cones are in front of or behind the focal plane, and the points of the scene belonging to these tips are likewise in front of or behind the focused distance. The distance between the two extreme points of the scene the intersection of whose cones in the focal plane is accepted as sharp is called depth of field.

If we wish to determine depth of field in advance, we have to know which factors affect the zone of sharpness.

Depth of field is increased:

By using small lens apertures;

By focusing the lens at a greater distance;

By using a shorter focal length lens.

Depth of field is decreased:

By using larger lens apertures;

By focusing the lens at a lesser distance;

By using a longer focal length lens.

You can determine depth of field easily

with the help of the depth-of-field scales engraved on the lens barrels of 35mm cameras and the 2¼″ × 2¼″ single-lens reflexes, or on the focusing knobs or backs of other cameras. These scales are generally computed to a relatively low standard, but they are satisfactory under average conditions. If you are more critical, and subjects at borderline distances from one another must show great sharpness, then *use the next smaller f/stop* than the one you found on the engraved scale.

There is a wide variety of uses regulating depth of field to achieve more satisfactory results in depth composition. One time we may throw the background out of focus to keep the subject from blending into the background. Another time we may wish to extend depth of field from the close foreground to the far background in order to make all the compositional elements of a picture sharp. Since only the specific situation determines what should be sharp in the picture and what should not, no rigid rules may be set. I may, however, give a useful bit of advice: Always keep the regulation of depth of field in mind and use the opportunities it offers.

PLAYING WITH PERSPECTIVE

Since the three-dimensional effect is closely related to perspective, we have to know something about it if we want to use this very potent method consciously in photographic composition. This idea is much more complicated in photography than in any of the other visual arts, since many factors determine whether the perspective of a picture is correct or incorrect. Because one or more of these factors can be changed, perspective may be manipulated at will, and may achieve unusual and pleasant results.

When we wish to deal with an idea that may be shaped at will, we have to do it in comparison with some standard. The vision of the human eye is the most obvious one. But this is complicated by the fact that the angle of view of the normal lens does not

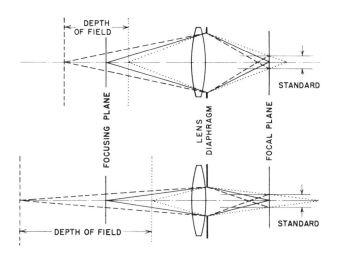

Diagram 7. Explanation of Depth of Field

match the angle of view of the human eye. The approximate diagonal of the negative format was chosen as the normal focal length of the taking lens, but about double this length would be the proper one to give the same angle of view that the human eye has.

On the other hand, the perspective rendition of a picture depends upon the distance from which it is viewed, together with the focal length of the taking lens. A photograph renders the same perspective that was caught by the taking lens *if* it is viewed from a distance equal to the product of the multiplication of the focal length by the degree of enlargement. Of course, when we look at a picture, we don't know anything about the focal length of the taking lens or the degree of enlargement. Our viewing distance is determined only by the size of the print. This is called the *convenient viewing distance*—when the entire picture is within the viewing angle of the eye. The distance at which it is convenient for us to look at an 8″ × 10″ print is about 15 to 17 inches. As soon as we look at a larger picture, we automatically move it farther away, or closer if the picture is smaller. (The convenient view-

ing distance for an 11″ × 14″ print is about 20 to 25 inches, and about 10 to 12 inches is that distance for a 5″ × 7″, depending upon individual capacities.)

The focal length of the normal lens requires use of a viewing distance that coincides with the convenient viewing distance. This can easily be calculated by multiplying the focal length of the lens by the degree of the desired enlargement. This was one of the reasons why those particular focal lengths were chosen as "normal," though their angles of view did not correspond with the angle of view of the human eye. This difference between the vision of the human eye and the rendition of the normal lenses provides an explanation for the sometimes disappointing results of inexperienced photographers.

Every aspect of perspective is based upon (1) the angle of view of the average human eye, and (2) the viewing distance from the picture. Since, in photography, factors of these two basic requirements may be changed, our perspective sense may be cheated.

For example, in comparison with the field of view of the human eye, the normal lens actually gives a wide-angle view; but in comparison with the convenient viewing distance, the perspective rendition of the normal lens is correct. From this discrepancy arises the following: A scene closed into the format of the print does not give exactly the same effect as the scene we saw in nature (even if we do not now take into account the colors, the depth of field, the different tonal qualities, the movement, and the like). We can give a picture a greater or lesser degree of attractiveness. Thus, it depends upon the skill and taste of the photographer whether he is able to give the spectator a picture that is a close replica of the scene, or one that is perhaps more attractive than the scene was in reality. He may even fail to produce a picture that is a recognizable image of the scene he saw in his viewfinder. To raise a picture's attractive power is the main goal of photographic composition, and the changing and choosing of perspective at will is a very effective tool in the hands of the creative photographer for achieving this goal.

Perspective rendition shows the relationship between objects lying one behind the other from foreground to background. Perspective helps the viewer to visualize the distances between these objects and also to estimate their sizes. This visualization depends upon the relationship of distances between camera and foreground and between foreground and background. If the distance between camera and foreground is small (when we use a wide-angle lens) in comparison to the distance between foreground and background, the subjects lying between foreground and background are seemingly farther from each other. If we take the photograph at a greater distance from the foreground with a long-focus lens, these relationships become changed: Foreground and background seem closer to each other, and so do the objects lying between them.

How does this relate to angle of view and viewing distance? In explanation, I shall take the situation, say, with a 200mm long-focus lens.

Concerning Angle of View

The 200mm lens narrows the angle of *human* vision by about half. Thus the print shows only a segment of the image seen in nature with all its surroundings and foreground. Because of the telescopic effect of the lens, unrecognizable details of the background become recognizable in the print, and therefore appear closer. More distant objects in the scene, which did not arouse any attention, become emphasized elements in the foreground of the picture, and since they are closer to the background, the perspective effect of the entire picture becomes compressed.

Concerning Viewing Distance

If we were to look at an 8″ × 10″ print from the proper viewing distance—about 5½ feet

in the case of a 200mm lens—the print would appear as it would if we looked at the scene through a square hole in a piece of cardboard which narrowed our angle of view to that of the 200mm lens. The details of distant objects would be as little recognizable as they are in nature, and our feeling would be that the scene is just a simple cropping of a part of the entire field. It would not arouse any attraction. However, nobody looks at an 8″ × 10″ print from 5½ feet, but from about 15 to 17 inches. From this distance details become easily recognizable, and the entire picture creates an effect we did not see even in nature.

Summing up: Angle of view and viewing distance work together to create a certain perspective rendition in the photograph. Since the components which determine this perspective rendition can be changed in relation to those two standards, our perspective sense can easily be fooled.

EFFECTS OF VARIOUS FOCAL LENGTH LENSES

Perspective is partially manipulated by selecting the focal length of the taking lens.

The long telephoto lens compressed the perspective of this picture and emphasized the regular repetition of figures and lines.

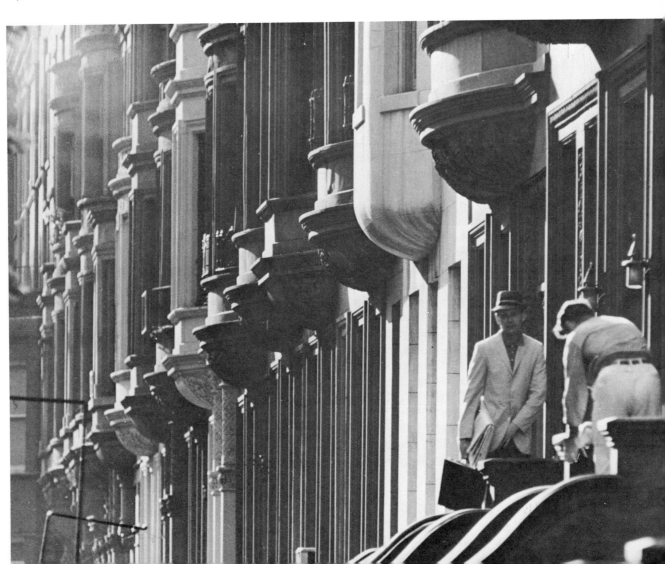

But changing the focal length of the lens alone is not enough to control all the compositional elements of the photograph. Usually, we have to change the position of the camera to get that vantage point necessary to control the perspective rendition of the picture and the line and figure effects. In order for us to obtain the most favorable effect in a picture, all the compositional elements have to work together—framing, perspective, line effect, figure effect, and so on. Lenses of varying focal lengths give different renditions with respect to these compositional elements.

Short-Focus Lenses

Short-focus lenses, in consequence of their wide angle of view, capture a large vertical and horizontal field in the picture. Objects lying quite close to the camera are incorporated into the picture area, and in this way the relationship between the camera-foreground and foreground-background distance is changed. The background is seemingly farther away, and similarly, the distances between objects lying in the middle ground of the picture area are increased. Depth of field is increased also, and we can achieve a zone of sharpness from the close foreground to infinity with a relatively large lens aperture. Convergent lines are more sharply convergent and the diminution of figures lying one behind the other is exaggerated.

We can use these features of the short-focus lenses very well for increasing the illusion of depth. On the other hand, these exaggerations may cause problems. For instance, not only do the horizontal lines, and the lines leading into the depth of the picture area converge, but so do the vertical lines. This is why buildings seem to fall over when we fail to hold the camera level. Another trouble caused by the exaggerated depth of field of the short-focus lenses is that the main subject or the main situation may appear too closely related to a disturbing background and may not stand out well. Similarly, the wide angle of vision of short-focus lenses may incorporate into the picture improper surroundings and thus decrease the emphasis on a subject we wish to isolate.

Since short-focus lenses exaggerate the diminution of figures lying one behind the other, this exaggeration produces a strange proportional rendition of faces and figures at a short shooting distance. To avoid this undesirable distortion, we must take care that parts of the subject do not get too close to the camera. We must not try to fill the frame with the head of a person when using a short-focus lens. It is better to use a longer-focal-length lens from a longer shooting distance in order to get the necessary size of the head.

We can use this exaggerated proportional distortion of short-focus lenses very successfully to obtain unusual effects when photographing subject matter with well-known proportions. The shorter the focal length of the lens, the more exaggerated the distortion, and the shorter the focal length of the lens, the greater the depth of field. Thus, the great depth of field of short-focus lenses also helps us to maintain sharpness over all the required depth of the picture area, even at short focusing distances.

Summing up the functions of short-focus lenses:

Capturing a large area in the picture;
Yielding great depth of field;
Increasing the illusion of depth;
Yielding an attractive line composition;
Producing unusual effects by exaggerated proportional distortions.

Two warnings:

Avoid proportional distortion (if not wanted) when photographing persons. Avoid the distortion of lines when photographing buildings, either inside or outside.

Long-Focus Lenses

Long-focus lenses capture a narrower segment of the field. The longer the focal length, the narrower the angle of view of the lens, and the greater the degree of mag-

MASSACHUSETTS	
PENNSYLVANIA	
VERMONT	
WISCONSIN	
PENNSYLVANIA	
MASSACHUSETTS	
MASSACHUSETTS	
NEW JERSEY	
KANSAS	
ILLINOIS	
MASSACHUSETTS	
CALIFORNIA	
GEORGIA	
WASHINGTON	
CONNECTICUT	
MARYLAND	
OHIO	
DISTRICT OF COLUMBIA	
MASSACHUSETTS	
WISCONSIN	
ILLINOIS	
NEW YORK	
MICHIGAN	
PENNSYLVANIA	
ILLINOIS	
ILLINOIS	
WISCONSIN	
MASSACHUSETTS	
RHODE ISLAND	
MISSOURI	
WISCONSIN	
SOUTH DAKOTA	
WISCONSIN	
NEW YORK	
NEW YORK	
ALABAMA	
WISCONSIN	
NEW YORK	
ILLINOIS	
LOUISIANA	
NEW YORK	
NEW YORK	
MISSOURI	

The simple construction of this picture—containing vertical and horizontal lines—provides a certain accent of solemnity. And the light tonal values may arouse a proper feeling for the memory of those sailors who died for liberty.

nification. Because of the telescopic effect of these lenses, distant objects appear closer in the photograph.

Since those objects which are to be accentuated as foreground objects of the photograph are actually pretty far from the camera, the ratio of distances between the camera and foreground and foreground and background is decreased. In this way the perspective rendition becomes compressed. Because of this compressed perspective, objects distributed into the depth of the picture area do not show much diminution. This decreased diminution produces an illusion of shorter distances between those objects. Depth of field is also decreased, and because of the shallower zone of sharpness, unwanted details of background may be thrown out of focus. With the narrower angle of view we can isolate important subject matter very well by separating it from perhaps improper surroundings.

Despite the compressed perspective rendition of the long-focus lenses we may achieve the illusion of depth by regulated depth of field. This illusion may be strongly supported by increasingly dense aerial haze. Aerial haze may produce a disadvantageous situation also; namely poor contrast.

43

Since the long-focus lens selects only a small segment of the whole area that we see, the appearance of the aerial haze increases as the area of the selected segment decreases. We can modify black-and-white picture contrast by using yellow, orange, or red filters, but the effectiveness of the filters is greatly influenced by weather conditions. The less transparent the air, the stronger the filter needed. In an extreme case no filter alone can help, and we have to use infrared film and an infrared filter.

We have noted that the third dimension becomes compressed through the use of long-focus lenses. How can we use this phenomenon in photographic composition? When I speak about depth composition I mean not only the placement of figures and lines and other compositional elements, but the arrangement of subjects in such a way that they build more than one group engaged in the same activity or holding the same attitude simultaneously. This does not mean in every case a real group of more

than one person or thing. It means an exact point in the picture where the subject or subjects are located. Groups in the background and middleground performing the same action as the main group strengthen and support the action of the main group and increase the effectiveness of the photograph. By using a long-focus lens these groups are made to appear closer to each other and their performance in the background becomes more recognizable and useful for emphasizing the content of the photograph.

The exaggerated perspective distortion of short-focus lenses may cause unusual proportional rendering of well-known subjects when we take pictures from a short shooting distance. This may be exceedingly dangerous in portraiture, causing unnatural facial proportions (big nose, small ears), or the limbs of the subject appearing too big in relation to the other parts of the body. The normal lens, of course, shows this kind of distortion also when we stand too close

The three elements of a landscape—foreground, middleground, and background—are clearly separated in this picture.

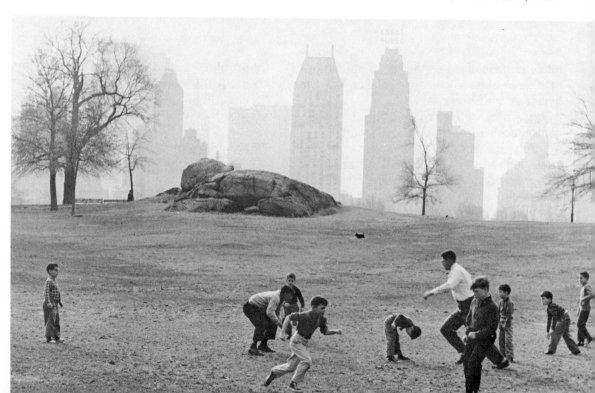

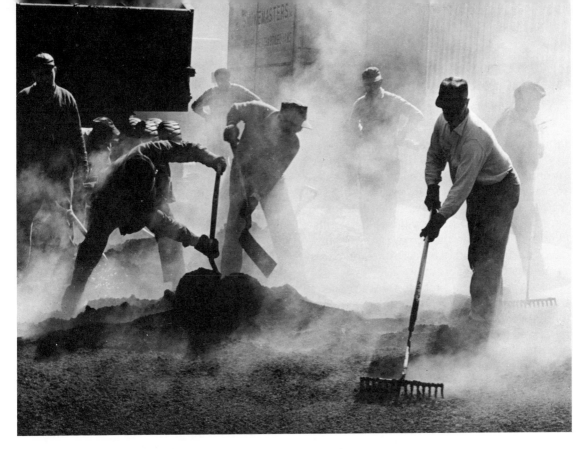

The vapor rising from the hot asphalt smoothes out the background.

to the subject. In these cases we have to switch to a longer-focal-length lens, which may give the wanted framing without forcing you to stand too close to the subject.

The viewfinder will show in advance which focal length lens has to be used to get the desired framing. In portraiture, the distance should not be closer to the subject than six feet. This six-foot minimum distance is easily maintained with the normal lenses of the larger-format cameras, since the image is large enough to fill the paper format after cropping during enlarging. But in 35mm photography, as a consequence of the much smaller negative format, the use of cropping during enlarging is limited. Therefore, we have to do this cropping in the viewfinder and by using the proper focal length lens. The proper focal length of the lens in most cases will be longer than the so-called normal focal length. In 35mm photography the 85-100mm focal length lenses are usually called "portrait lenses."

(Watch out: These lengths are almost double the length of the diagonal of the negative format, and the angle of view and perspective rendition of these lenses correspond to that of the human eye.)

Summing up the functions of the long-focus lenses:

Selecting a small segment of the area in front of the camera;

Bringing distant objects closer;

Compressing distances between objects lying one behind the other;

Throwing a disturbing background out of focus;

Emphasizing depth composition by more apparent repetition effect;

Rendering natural proportions in portraiture.

Two warnings: Avoid unsharpness in important areas of the picture caused by the shallower depth of field of long-focus lenses. Avoid the increased possibility of camera shake.

TREATING FOREGROUND AND BACKGROUND

Each picture which lays claim to acceptance as a work of art has to be subjected to examination on the basis of certain compositional rules. Adherence to these rules serves not only artistic purposes but also those simple goals which determine whether the photograph will be liked or disliked by viewers. In the ranks of these standards the treatment of foreground and background is very important.

Suppose that the picture shows a scene from nature in which living creatures and/or inanimate objects are to be found. These creatures and objects are usually distributed in the picture areas in three dimensions. That means that they are distributed within a certain space in front of a definite area that is accepted as the background. Whether the picture shows a definite foreground or not depends on the situation. Quite often the main subject and/or the main situation is placed in the foreground, and we do not have to consider the foreground as a separate entity.

But we must always take care of the background, whether it is connected with the content of the photograph or not. The choice of the proper background is often not ours to make. We have, however, very effective technical means to change the background relationships. In general, when the scene or situation does not show any connection with the background and is placed within a limited space, a dark or medium gray and quiet background is preferred. "Quiet" means the lack of sudden and chaotic changes in tonal values in the background area, and the lack of definite white and black spots or areas in the background, especially if these areas are sharply contoured. To throw these disturbing elements of the background out of focus we have to determine the depth of field.

Sometimes some kind of pattern in the background area may raise the effectiveness of the photograph. It may dissolve the effect of disturbing tonal qualities, especially when the distribution of these patterns points out the subject matter by line effect or figure effect. "Background" does not always mean some tangible object. The empty sky can be used as the background, as can a brick wall. But background is definitely something that belongs to the picture; therefore, it has to be treated in such a way that it will not ruin the effectiveness of the picture.

A simple example will explain how improper treatment of background may spoil a picture without the photographer realizing at the instant of exposure that he is doing something wrong. Imagine that he takes a photograph of a person in a room by available light, and that a lamp is hanging far behind the subject. Since the lamp is quite far from the subject it does not bother the photographer too much, if he is inexperienced or if in the heat of work he does not recognize the danger. But an experienced photographer knows that if the lamp in the background appears close to the head of the person, its out-of-focus image together with its irradiation causes a complete (or partial) diffusion of that area in which the subject's face was to appear. In this kind of situation the knowledgeable photographer chooses a camera position from which the lamp is covered by the head of the person. The situation is similar when windows are in the background, or when the photographer, by using a flash against some glossy surface, allows the light of the flash to bounce back upon some part of the picture. So, when a plain background is needed make sure it *is* plain.

Often the background belongs to the construction of the picture and is connected with the picture content. Sometimes it emphasizes the location or time of the story. It may emphasize and strengthen the content of the photograph by repetition or by contrast effect.

The appearance of the background may increase the three-dimensional effect of a photograph, or may spoil it if it is not

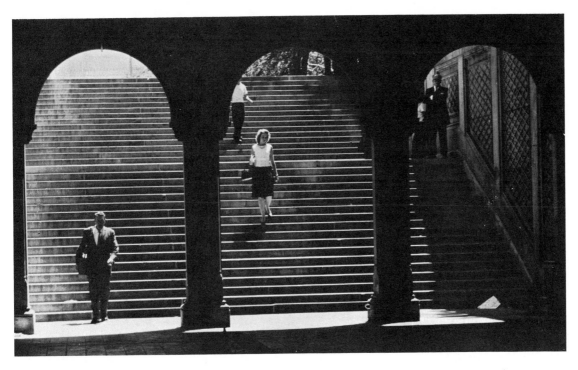

(Above) Stairs, columns, and arches are always welcome as decorative elements and/or as bearers of the picture construction. (Below) A foreground (whatever it may be) is a must for every landscape.

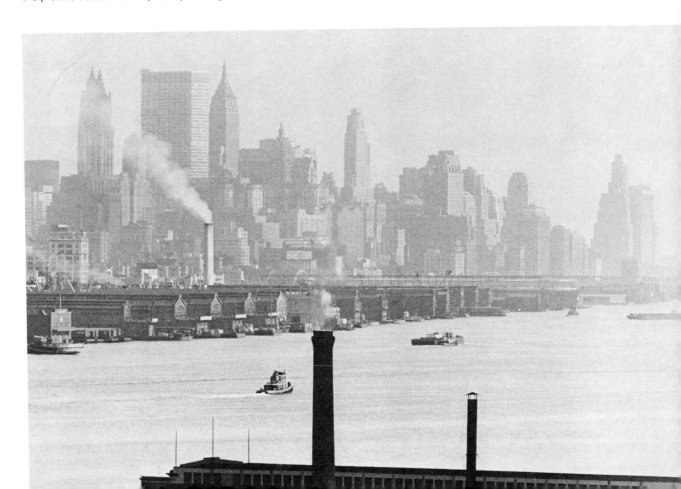

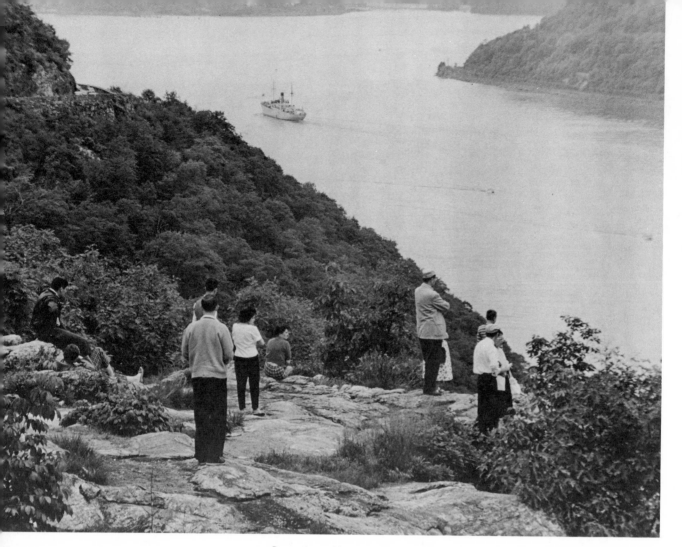

Properly positioned persons usually serve as good foreground for a landscape.

treated properly. But the appearance and treatment of the foreground play the most important role in giving the picture a three-dimensional effect. At the beginning of this chapter I discussed the effect of lines and figures as compositional elements which raise an illusion of depth if they are placed properly in the picture area. "Properly" means that they should emphasize the distances incorporated into the picture. They can do this when the foreground is used as a base; from there they grow into the depth of the picture (in the cases of line effect and diminution effect). They may appear alone in the foreground serving one or more of various effects (exaggerated diminution effect, similarity effect, contrast effect, haze effect). They may appear in the foreground in such a way that they serve as a decoration, or only to fill out an otherwise empty space, but they serve our illusion of depth, as well.

The photographer's will is fulfilled first by the selection of the focal length of the lens. By the selection of the focal length of the lens in connection with the position of the camera, he can determine the relationship between the foreground and background.

RELATIONSHIP BETWEEN FOREGROUND AND BACKGROUND

No rules can be set in connection with this relationship; only the photographer's imagination, taste, and needs can determine it. The discussion here will be how to implement your decision. Distance, tonal qualities, and the sharing of the picture area between foreground and background should be taken into consideration.

In the foregoing, I discussed how to change depth relationships by changing the focal length of the lens in connection with changing the shooting position. In this way, we may change the apparent distance between foreground and background. Of course, by those means we also change apparent sizes of objects in the foreground and background. This change of sizes gives

us another means by which we may express longer or shorter distances.

Regarding tonal qualities, so many variations may arise that my purpose will be best served by telling you what to be sure *not* to do. Thus, we must not show foreground objects blending into the background as a result of their similar tonal qualities. We can avoid this by using a light effect (backlight, fill-in light, and so forth), or by using filters to contrast the tonal qualities. I will discuss this in detail in the next chapter, but I would like to mention now an example to clarify the idea. If we take a photograph of a sunburned person with the blue sky in the background, we see in reality that the color of the person and the color of the sky contrast very well. If we were to use an improper filter, these two colors might show the same tone in the gray scale of the black-

The foreground strongly emphasizes the Christmas spirit. Without it, the picture would be just another conventional documentation out of the several thousand photographs taken every year at Rockefeller Center.

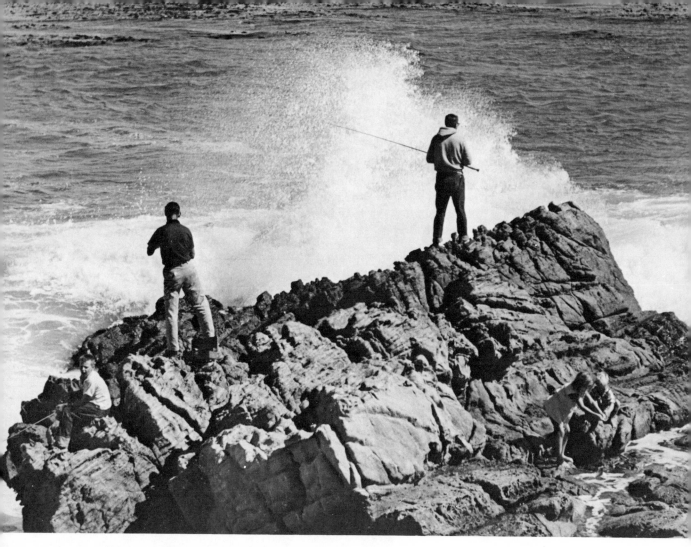

This is a simple composition. Both anglers are placed approximately into the Golden Mean line.

and-white photograph, and they would blend into each other. But when we use a medium yellow or orange filter we may darken the tonal quality of the blue sky and lighten the skin tone of the person so we gain sufficient tonal separation between subject and background.

The sharing of the picture area between background and foreground may also be regulated by the shooting *angle* of the camera. If the camera position is low and we shoot upwards, the foreground objects appear higher than the objects in the mid-

dleground, and the background may disappear and be replaced by the sky. If the camera position is high and the camera overlooks the scene, the background may disappear again and be replaced by the ground below the scene. In this case, foreground objects are less emphasized unless they are very close to the shooting axis of the camera. Between these two extreme cases I can imagine a lot of variations, and only the situation can settle which treatment should be preferred.

From a normal shooting position (this

means that the camera is held at a person's eye level and the shooting axis is horizontal), short-focus lenses render a greater foreground area in the picture, and the background becomes diminished. The shorter the focal length of the lens, the more sky will be incorporated into the picture area. When the focal length of the lens increases, sky areas disappear gradually and so do objects in the foreground. In this way, objects lying farther and farther from the camera become part of that area of the picture accepted as the foreground of the composition. At the same time, with the moving of the foreground into the center of the composition, smaller and smaller segments of the background are cropped out by the increased focal length, and the background area increases relatively. In an extreme case the foreground objects become parts of the background, and the perspective becomes so compressed that we would lose our three-dimensional impression if one of the means discussed previously were not applied (light effect, haze effect, regulated depth of field, changing tonal qualities).

PARALLAX

Parallax is the difference between what the viewing system of a non-reflex camera "sees" and what its lens sees. In the mind of a less experienced photographer, it is easily corrected by modern rangefinder cameras with built-in automatic parallax compensation, or by accessory finders which feature parallax compensation. But these instruments compensate only in the plane of the focusing distance. This means that parallax compensation determines only the correct frame (which is two-dimensional) in the focused distance, but it does not help in the correct alignment of objects in the depth (which is the third dimension). An example will explain the idea. If we took a picture of two candles set one behind the other and the second candle were completely covered by the first one when

viewed through the parallax compensated finder, the second candle may still be visible in the picture taken, because the camera lens sees from a position which may be two inches to the side of the finder.

This phenomenon jeopardizes our efforts for exact composition, especially when a superwide angle lens is used and compositional lines start in the close foreground, or an important figure is placed there. It may

Even souvenir pictures may be made by observing the rules of composition. The soft pattern of the out-of-focus UN Building serves as a pleasant background. The street sign and the "no standing" sign serve as balances for the off-center main figure.

The exaggerated perspective diminution given by the 28mm lens produces the distance effect, which is strengthened by the slightly out-of-focus rendition of the background. However, this did not decrease the feeling of the obvious connection between the foreground figure and the background objects.

happen that this object covers a greater or smaller part of the picture area than we would have liked, and the lines start in quite another place than we had supposed. Because of this we are unable to build a proper construction of the composition. A single-lens reflex camera is a great help in this situation, since single-lens reflex systems are free from parallax. It is not easy to compensate for parallax in the viewfinders of rangefinder cameras. This phenomenon does not make too much difference in average picture-taking situations, but in cases like the above I take it into account very carefully and I act as follows:

I set the parallax-compensating adjustment of the viewfinder to infinity. I determine the correct setting of lines and figures by looking through the viewfinder; then I lean sideways or I lift the camera to place the lens into the position the viewfinder previously occupied, so the lens will record the same image I saw through the finder. This is not easy to do without a tripod, but after some training it can be done. It is unfortunate that in some cameras it is impossible to set the automatic parallax compensation to infinity when the lens is focused at close distances, since it is coupled to the lens focusing. In determining correct framing and depth composition we have to take this circumstance into account. The situation is similar in twin-lens reflex cameras, but not as critical since users of twin-lens reflexes only have to worry about vertical parallax. The camera is almost always held with the viewing lens directly above the taking lens, which is less dangerous in depth composition than the horizontal parallax of the rangefinder camera in vertical picture compositions.

5

RENDITION OF TONAL VALUES

REPRODUCING COLOR IN BLACK, GRAY, AND WHITE

The Greek origin of the word *photography* signifies that light is used to bring a picture into existence. This is only in the sense of the basic chemical activity of light rays. But in terms of composition, light is used also to give an attractive appearance to the picture. The light does this by producing different tonal values from the highest white to the deepest black. (In this case, the reflected light from the darkest area of the picture is less than the minimum exposure for the particular film.)

Since, in black-and-white photography, the picture is reproduced in the gray scale instead of in the colors natural to human vision, it is essential to know how to transform these colors into gray tones. More exactly, it is essential to try to achieve a pleasing effect in a black-and-white print, despite the lack of color. The color photographer has a much easier job than his black-and-white counterpart. Color photography has its own compositional rules, but these rules are to be applied consciously only at an advanced level. I am sure that a tyro would produce more pleasing results in color than in black-and-white.

A special sense has to be developed to avoid disappointment in black-and-white photography. It is fortunate that this sense can be developed quickly, but sometimes even experienced photographers can be led astray despite their highly developed sense.

If we can be fooled when transforming colors into black and white, we can fool others in turn. And this possibility of being misled and misleading others is the basis for using the reproduction of colors in different ways for compositional purposes. That means that we can render the black-and-white tonal values of one or two colors differently from their accurate translation in the gray scale. "Accurate" means presenting the same illusion of light-dark values of different colors as they are comprehended by the human eye. Since this illusion has been determined by science and is set in diagrams and in numerical values, we have an exact standard for measuring or emphasizing any deviation from human vision.

FILM AND COLOR

Diagram 8 presents the color sensitivity of two types of black-and-white film in comparison with the color rendition of the human eye. These two types of film are easy to recognize by the relationship between the daylight and tungsten ASA exposure indexes recommended by the manufacturers. If the daylight index is higher than the tungsten—such as in the case with several panchromatic films—its color rendition is close to that of the human eye under average daylight conditions. If the tungsten index is higher than, or the same as, the daylight index, this means that the film features an increased red sensitivity. These films are the more commonly used ones today. It is advantageous to use such a film under artificial light conditions, for its increased red sensitivity responds more effectively to tungsten light sources, which are rich in

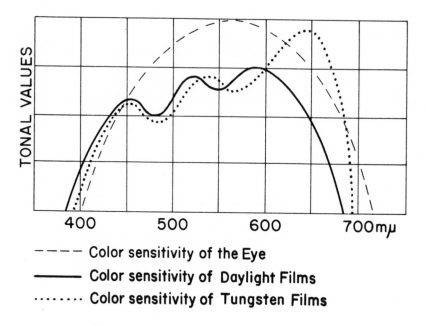

―――― Color sensitivity of the Eye

——— Color sensitivity of Daylight Films

········ Color sensitivity of Tungsten Films

yellow and red light rays. Under both regular daylight and artificial light conditions these tungsten-type films render red lighter than the human eye does.

Unfortunately, all black-and-white films display an increased blue (and ultraviolet) sensitivity in comparison with the human eye. This causes a lack of sufficient gray tone in the sky, and white clouds do not show enough separation from an exceedingly light sky. In the worst cases, clouds may disappear completely in the white background. Since a monotonous white sky is not advantageous in black-and-white photography, we have to correct the situation by using filters. The blue sensitivity of modern emulsions is very much less than that of older emulsions. So, when the blue saturation of the sky is sufficient no filter is needed to make clouds visible.

FILTERS

We should use a filter only when we wish to lay more stress upon the sky area of the photograph, in regard to stronger separation of clouds or other light colored objects (buildings, birds, persons) from the sky. The stronger the filter used, the greater the separation obtained. The degree of the strength of the filter (in its capacity of darkening blue) is determined by its place in the sequence from light yellow to dark red. Thus, the light yellow filter darkens blue less than the medium yellow, which darkens blue less than the orange filter. Finally, the last members of the sequence, the various densities of red filter (light, medium, and dark) render the ultimate effect in darkening blue.

How strong a filter has to be used de-

pends on the saturation of the blue color of the sky and on the effect which the photographer wishes to obtain. Further, it depends on the characteristics of the film. It is strongly recommended, therefore, that the photographer learn well this feature of the film he is using, in order to be able to achieve the desired result. Some exposures of a color test chart will show how the film performs when various filters are employed. Of course, it is recommended that the photographer take these test exposures not only with the filters of the yellow-red family but with the other available filters also (green, green-yellow, and blue) in order to acquire knowledge about all possible filter-film combinations. Diagram 9 shows the basic effect of the various filters.

MANIPULATION OF TONAL VALUES

Let us now see how we are able to change the apparent tone of various natural colors. We must do this to achieve our goal of producing pleasing results, and on this count we may rank manipulation of color values among our compositional means. When our sense for the proper transforming of color values into black, gray, and white has been developed, and we have an assured knowledge of the color rendition of the film used, we can recognize those colors which will blend into each other in the black-and-white photograph. To make this transformation easier, we may use a piece of dark blue glass. Looking through this glass we see the scene almost as a

Diagram 9. The differently shaded areas indicate the degree of absorption of a filter in relation to a particular color. The darker the color, the greater the degree of absorption.

monochrome, as it would appear in a black-and-white print. In this way we are not influenced by the pleasant but irrelevant attractiveness of the colors of the picture area. Thus we can judge more easily whether the effect of the scene transformed into the conditions of black-and-white photography will be pleasing. By our knowledge of how to use different filters, we are able to separate colors in the black-and-white scale if it is necessary. In this way we may emphasize some areas of the picture by making them lighter and we may de-emphasize other areas by making them darker.

For instance, the visual effect of the natural green colors of spring may be preserved in the picture if we use a light-green or a yellow-green filter. Since most panchromatic films are weak in their sensitivity to green, the green of nature usually comes out darker in the picture than it appears to the eye. If a lighter rendition is needed we should use a green filter.

The filters of the yellow-red family are used not only to overcome the inherent blue sensitivity of film. They are often used to dramatize, or perhaps overdramatize, the sky area of the picture. In these cases—as I mentioned previously—the darker members of the sequence should be used. In architectural photography the red filter is often used to give a dark gray tone to the sky, and in this way point out the building more distinctly.

Darker filters (dark yellow, orange, or red, or even infrared in connection with infrared material) are also used to overcome aerial haze. On the other hand, we may emphasize aerial haze by using a blue filter. We can do this to achieve the feeling of immense distance, since aerial haze produces this effect. Sometimes sufficient aerial haze does not exist, and we have to produce it by this trick. Do not worry about the lack of aerial haze when using telephoto lenses, because only a small segment of the area that we see is captured and brought close

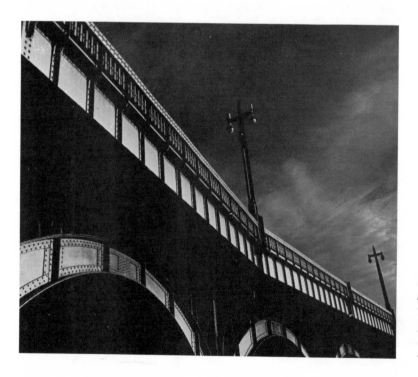

The pure photographic effect of this picture was produced by using a red filter and contrasty paper during enlarging, thus heightening the contrast of tonal values. This exaggerated contrast pinpoints the construction of the picture and simplifies its appearance.

to us together with aerial haze. In this kind of close-up, aerial haze is present in greater quantity than is needed, so we have to use a strong filter in order to depress it.

A haze-like effect (and unsharpness, too) is produced on the film by invisible ultraviolet radiation. In cases in which ultraviolet radiation may occur (at the beach on very clear days, and at altitudes over 8000 feet), we have to use a UV filter to avoid this phenomenon and the resulting unsharpness. (Unsharpness is caused by the fact that many lenses are not corrected for this radiation, which is not visible to the human eye, but the out-of-focus ultraviolet image of distant objects is nevertheless recorded by the film.)

When photographing with speedlight, and the existing incandescent illumination, which is rich in yellow and red light rays, is too strong, use a blue filter to cut down this effect. This does not affect the image on film produced by the blue rays of the speedlight. In this way, double images of moving subjects and unsharpness will be avoided.

We are also able to change the tonal values of certain areas when enlarging. We may darken a particular area of the print by burning-in, or lighten it by dodging. These procedures are used mainly to overcome the narrow tonal latitude of the paper in comparison with the great latitude of the film. So, during part of the exposure time we may hold the light back from the shadow areas by using our hand or a special tool (this is dodging) or we may give additional exposure to the highlight areas through an appropriately shaped opening in a cardboard or of our hands (this is burning-in). We can use these means not only to maintain the correct rendering of tones but to give a different appearance to otherwise correct tonal values. For example, if a light area appears somewhere in the picture in a way that diverts attention from the main subject, we can darken this light area by burning-in. We often have to darken edges of the print to give greater accent to the content of the photograph. Conversely, we may lighten faces or other important areas of the picture (especially in backlighted situations) by dodging. Since these areas may turn out too dark without dodging, their details would be depressed or completely unrecognizable.

The long, narrow strip of light points like an arrow to the funny appearance of human curiosity.

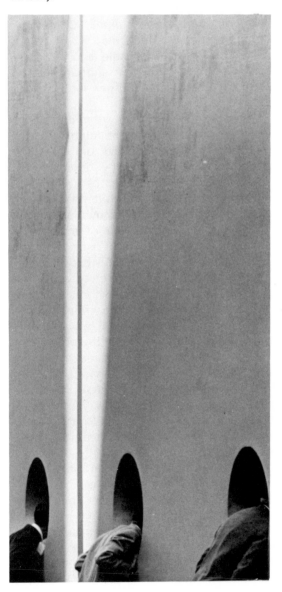

TONAL VALUES

Since we are now able to manipulate tonal values almost at will, we have to learn their effect in connection with photographic composition. As a general rule, light tones attract the spectator first, while dark tones are recognized later. It is advantageous when the main subject contains the lightest parts of the picture area, or is surrounded and emphasized by light tones. Moreover, a pleasing photograph should contain all or most of the tonal values from clear white to deepest black. Of course, there are special effects also when only a part of the entire tonal scale is to be represented (high key, low key, silhouette, high contrast, graphic, and other kinds of effects).

Among the tonal values, the middle tones are represented in overwhelming majority, then the dark values, and only a small amount of highlights. Why only a small amount of highlights? Because highlights represent the complete whiteness of the paper background, and if shown on a great area, cause a complete lack of any kind of detail. Imagine a picture of a bride which lacks details in her beautiful dress. When photographing even completely white objects, in the interest of achieving a pleasing effect the greatest part of the white area has to be presented as a very light gray and only the few outstanding parts of the object can appear perfectly white. It does not make any difference whether these parts are wholly struck by light or partially, because even when they are totally illuminated, slight variations in reflected light—due to the surface qualities and texture of the object—decrease the possibility of coherent white surfaces. In photographic terminology these coherent white areas are known as "chalky" surfaces. Their presence is definitely unfavorable.

Since several light areas can be present in a picture, it may happen that some of them (or perhaps only one) will appear close to the edge of the picture. This may cause a disturbing effect, since it leads the attention away from the main picture area, especially if it is not essential to the content of the picture. This kind of independent light area must be avoided. Even if such a light area is connected with the picture's construction, in the form of figure effect, it may cause the same result. In the case of line effect, the situation is reversed, since the eye, caught by the beginning of the line at the edge of the picture, is led into the picture.

The presence of completely black areas is less dangerous, if they are balanced by similar black areas, or by smaller light areas. It is a tenet of photographic esthetics that a large black area can be balanced by a small white one. Since the eye is attracted to light areas, and passes over dark areas, a light area has several times the weight of a dark area in the construction of a picture. Anyone who has studied even a small number of pictures knows that this is true, but only the photographer's sense and experience can determine the correct relationship and balance between lights and darks—their size, their distance from each other and from the main point of the picture, and their position in the picture area. It is advantageous when they are placed in the opposing Golden Mean points of the picture, but there are other positions also, such as the vertices of a triangle or in other geometric figures.

LIGHT AND TONE

On a purely theoretical basis, the attraction of a picture depends upon how the different tonal values are distributed. By

The lighted obelisk at the left serves as a counterbalance for the mass of the fountain at the right; moreover, it breaks up the emptiness of the black sky at the upper left.

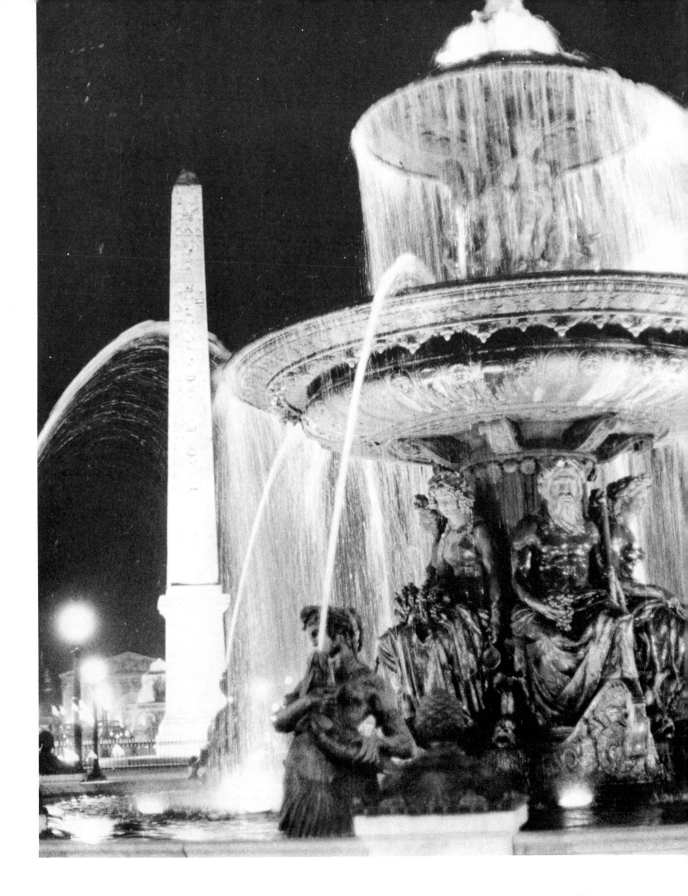

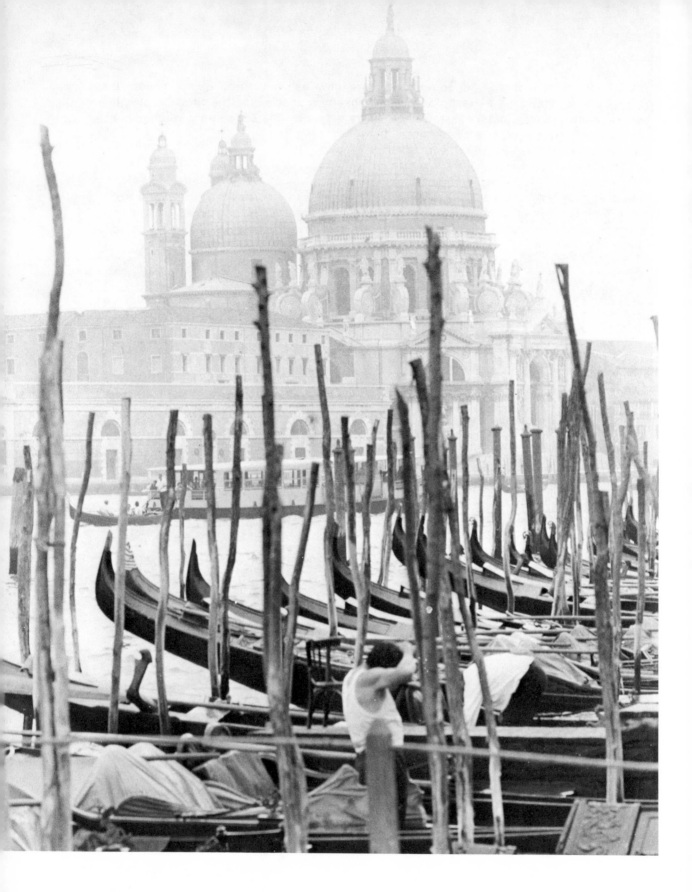

skillful coordination of all the compositional means, we may set the exact place of these tonal values in the picture area. But it is not enough that light produced those tonal values which we arranged into the construction of the picture. This is the most simple action of light. A more important action of light is that it may bring into existence differently shaped figures and lines, and other compositional elements, which

we may use according to our needs. By changing or selecting the direction of light, we may alter the appearance of shapes at will.

DIRECTION OF LIGHT

There is no doubt that the direction from which light falls in the picture plays an important part in determining the appearance

(Left) The different tonal qualities of foreground and background create the illusion of distance. Otherwise, the cathedral would "stick" to the foreground. (Below) The large dark statue in the white area and the hotspots of the two small statues in the black area maintain a proper balance for the whole picture.

The center of interest is in the Golden Mean position and in the lightest spot of the picture area. If I were to make this print again, I would definitely burn in the light areas of the pavement above the squirrel.

of the picture. And this direction is essential in determining the compositional means which may be used. It often happens that the lighting itself produces those means.

For an examination of the influence of light direction, I have to categorize the idea. So I shall deal with front-, side-, and back-lighting. The subject is frontlighted when the greatest part of it is struck by light from the main light source. This means that the direction of light is close to the camera axis. When the illumination comes from a direction which is less than 90° and more than 30° to the camera axis, it is considered sidelighting. When the main light shines from an angle to the camera axis of more

than 90°, and the shadows of the objects fall between them and the camera, the scene is backlighted.

Two of the three types of lighting have a typical effect on the appearance of the picture. The frontlighted picture is usually light, and the backlighted photograph is rich in dark tones, and contains sparkling highlights. The sidelighted picture shows a less distinctive appearance than the two others. We may say that it is most usual; however, in certain cases it may display the features of a backlighted picture.

There is no doubt that frontlighting causes the fewest technical difficulties, by which I mean unwanted contrast in important parts of the picture, say on faces of persons. The lack of sufficient contrast in the picture area is also rather troublesome, especially when light-colored subjects appear in a light environment. In this case, in order to gain more contrast, filters have to be used according to Diagram 9. But you have to keep in mind that you can do this only within certain limits, because filters separate only complementary colors and those close to them. Thus we may separate a girl dressed in yellow from the blue sky by using a yellow filter, but no filter can separate a girl's blue dress from a similarly blue sky.

The possibility of lightening or darkening areas by using filters offers us an effective means to point out subject matter. Frontlighting offers the most advantageous situation for this kind of playing with the apparent tonal values of the different colors, since the colors are most thoroughly saturated when frontlighted. As an example, maintaining the sky's apparent tonal qualities is one of the most delicate problems in black-and-white photography. The sky appears in the picture area, with or without clouds, mostly in a medium gray tone. The sky is almost never blue enough in the direction of the sun to make sufficient filtering possible even when the strongest filters of the yellow-red group are used. But when the sun shines behind us we may some-times get such a full blue saturation of the sky that perhaps we may achieve the needed gray tone without a filter. Or, to go further, we may overdramatize the sky by using a medium yellow filter. The situation is the same with other colors; filters produce their best effect when the scene is frontlighted.

Do not worry about the effect of filters when the scene is sidelighted, for this direction of light does not exert too much influence on the effect. But in a sidelighted photograph larger shadow areas appear than in one which is frontlighted, and since these shadow areas receive their illumination from the skylight, a filter may cut down too much of the reflected light. Thus, shadow areas may appear darker than is desirable, when the sky is clear blue. But if many clouds appear in the sky, or the sky shows a hazy appearance, the illumination of the shadows is not dangerously blue. The effect is similar when subjects are photographed in green surroundings. Since our films are less sensitive to green than the human eye, we do not recognize the dangerous green reflection, which is, nevertheless, reproduced by the film in the form of severely underexposed shadow areas. So we have to be aware of the reflected colors of the shadow details. We may help remedy such a situation by doubling the estimated exposure time, or by filling-in with light.

Filling-in with light may be accomplished by using any kind of light-colored thing (handkerchief, sheet of paper, book), as a reflector when natural fill-in objects are not available. Natural fill-in objects are walls, pavement, clouds, sand, water, and the like, which reflect sufficient light into shadow areas. We can fill in shadows by using flash or speedlight, too. But we must not overdo this, or the picture will look as if two suns were in the sky, and the subject will become unnatural and flat. When shooting inside where the illumination is either by available light or by floodlight, shadow fill is of greater importance than outdoors. By using only available light (either daylight or artifi-

cial light), the main illumination comes mostly from only one direction, and the contrast between the well-illuminated and the darker parts of the subject is so great that strong fill-in is needed. We can do this well by using bounced flash either directed at the ceiling, the wall, or the floor. Just as in the case of outdoor picture-taking we have to estimate carefully the expected effect of the fill-in in order to avoid exaggeration. By using floodlights the situation is made easier since we can apply as many lights as we need and we are in complete control of the lights, regarding direction, strength, and distance from the subject.

Filling-in shadows grows more important in backlighted closeups and medium closeups. We have to use methods similar to those used in sidelighting. When taking photographs of larger areas, we have to double the measured average exposure time in order to get sufficient shadow details in the negative, since the greatest part of the picture contains these details. To maintain the technical qualities of the photograph is not our only goal when taking backlighted pictures. There is the more important goal of using light effects for compositional purposes.

As I mentioned in the previous chapter, the direction of light may produce compositional elements that can be used in the construction of a photograph. Backlighting is especially useful in this regard, so I shall examine situations which indicate the use of backlighting. These situations are closely connected with the camera vantage point, and it must be consciously determined in order to make use of the possibilities offered. Line, figure, and haze effects are produced by backlighting, and by using these effects we can evoke a definite feeling of depth. Since shadows running toward the camera represent line effect, it is obvious that we can catch them to best advantage when the camera overlooks the scene. Figure effect comes into being this way: The contours of the objects are accentuated strongly by the illumination, and an obvious separation is created both between one object and another and between the objects and the background. This phenomenon is most effective when the background is dark and quiet. So, in order to get the best effect, we have to take care of the appearance of the background.

Haze effect is an inherent quality of backlighting, and by use of it we may suppress unwanted details of the background and increase the illusion of depth. In any case, by the increased contrast caused by backlighting (although great contrast is sometimes unwanted) we may accentuate some subjects, and depress others. Another favorable feature of backlighting is that it may simplify the construction of the picture by emphasizing shapes and lines, and at the same time subduing those areas of the picture that do not enhance its appearance.

Strictly speaking, the rendering of surface texture may not be termed a compositional means in photography, but it is one of the most noticeable qualities of a photograph, and I will discuss it in terms of the direction of light.

Oblique light is the most favorable form of illumination for achieving this effect. The surfaces of most subjects are uneven or textured, being made up of hills and valleys. By using oblique light the hills are well illuminated and the valleys are in shadow. In this way, we produce tonal values which vary within small areas of the surface. As a result, the texture of the surface becomes strongly emphasized. Since backlighting and to a lesser degree sidelighting often appear as oblique light, the rendering of surface texture can be accentuated by these forms of illumination.

Flare is the primary danger in backlighted situations. It is seen in the form of circles and/or spots on the negative, or the entire picture may be fogged or show a lack of sufficient contrast. This phenomenon occurs when light strikes the front element of the lens at a certain angle. Neither modern coatings nor lens hoods always help, especially when the sun shines at a low angle. In

The contrast of the very dark pavement in the foreground and the lighter part of the picture, which includes the George Washington Bridge, enhances the composition of the subject matter.

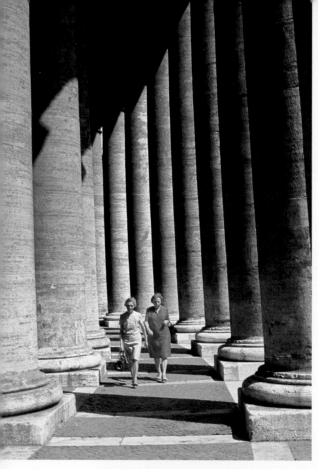

(Left) Parallel lines at the edges of pictures can be dull, but the diagonal shadows in the upper part of this picture breaks up the dullness. Moreover, the eye-catching red spot, positioned in the Golden Mean point, provides proper balance of the photograph. (Below) The overspan of the bridge satisfies the susceptibility of humans for geometric figures.

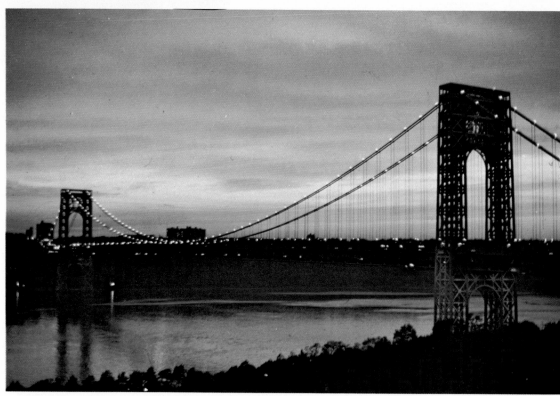

(Right) A good example of the rhythmical decreasing of patterns. (Below) This is basically a two-color photograph of yellow and green, but the tiny patches of red flowers give a lift to the otherwise dull appearance of the picture.

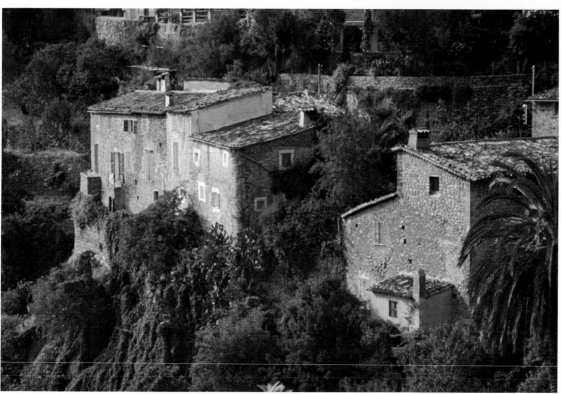

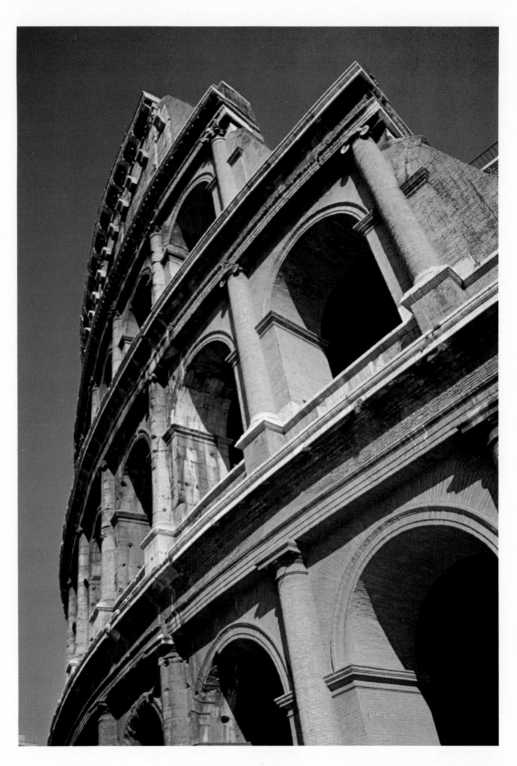

The exaggerated perspective of the wide-angle lens points out more dramatically the structure of the Colosseum in Rome.

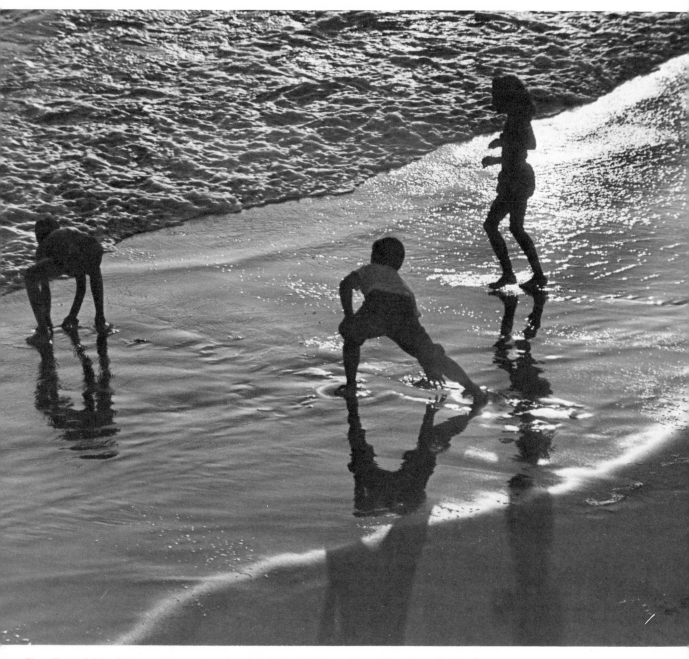

The effect of this photograph is produced mainly by light. It also shows other ingredients of photographic composition, diagonal lines, patterns, and adherence to the Golden Mean rule.

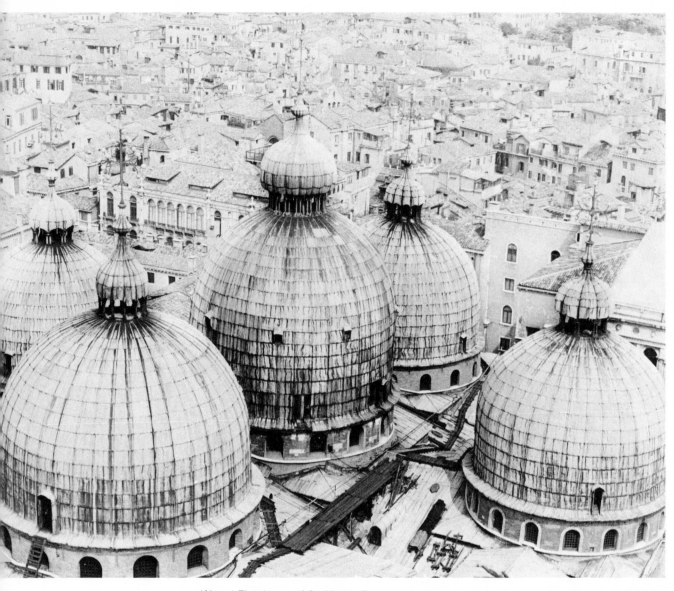

(Above) The domes of St. Mark's Cathedral in Venice tend to blend into the background. *(Right)* Darkroom trickery, utilizing a mask, was used during additional exposure of the background to make the domes stand out.

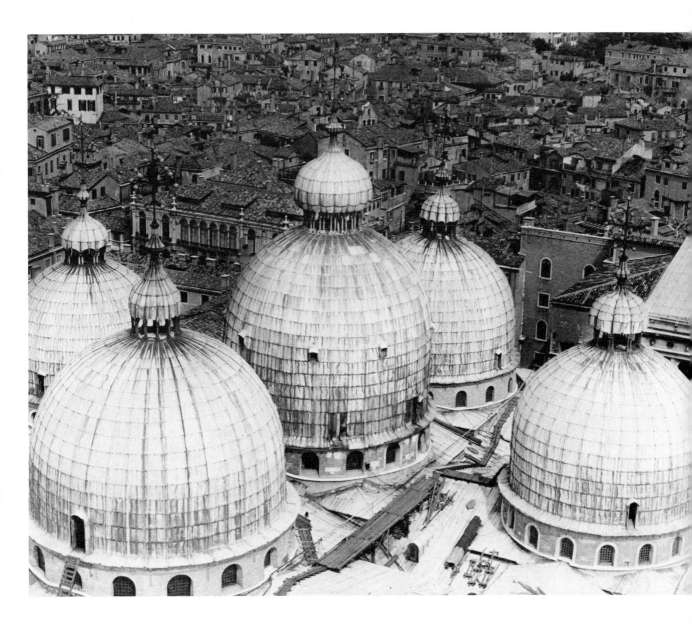

that case we have to create a separate shade for the lens. We may find a place where a branch, or a sign, or some other object will create shade. A person using a single-lens reflex camera can recognize flare immediately, and by a little change of the camera axis, or by holding one's hand above the lens, can overcome this. Flare may also be caused by reflecting surfaces (water, glass, or metal) and we have to take these into account as well.

Another problem which may cause dissatisfaction with backlighted photographs is the duality of the contrast within the negative. As a consequence of the illumination great contrast is shown between the highlights and the shadows. But within the shadow areas a sufficient degree of contrast does not exist. Since, in a backlighted photograph, shadows usually take up most of the surface of the picture, it is vital to maintain a sufficient degree of separation between shadow details. To solve this problem a proper choice of film-developer combination has to be made and a fitting processing technique has to be used. The goal of this technique is to achieve soft negatives without blocked-up highlights but with sufficient shadow density and contrast. Therefore, besides choosing a soft-gradation film and a soft-working developer, the manufacturer's recommended developing times have to be shortened by about 20 to 30 per cent. After development put the film into clear water for about one or two minutes instead of into an acid stop-bath (the water should be about the same temperature as the developer) and agitate only for the first few seconds. The developer, which saturates the emulsion, continues to work until its power becomes exhausted or is otherwise hindered. In the highlight areas the developer becomes exhausted in a short time, while in the shadow areas its power remains relatively unaffected. In this way the shadow areas gain longer developing time than the highlight areas. It is obvious that they gain more contrast and density, while the highlights remain almost as they were when the film was transferred to the water bath. This difference is caused by the fact that in the highlight areas more silver-bromide crystals had used up the energy of the developer than in the shadow areas, and more hydrogen-bromide was produced there than in the shadows (hydrogen-bromide restrains the effect of the developer).

Since only those silver-bromide crystals which received sufficient exposure are developable, the exposure time has to be determined in such a way that the important shadow details receive sufficient exposure. Close reading with a hand-held exposure meter is the most effective method for this. Since exposure meters are only aids for determining the correct exposure, we have to take into consideration the importance of differently illuminated areas. After the meter is pointed toward various points of the picture area, we can calculate the exposure which fits our needs. I may call the result of this calculation the corrected meter reading.

If shadows and well-illuminated areas are about equal in the picture area, we should double that exposure time (in case of backlighting) which we determined by the average reading method. Average reading means that the exposure meter was pointed directly toward the picture area from the position of the camera.

Conclusion: Frontlighting offers the greatest opportunity for manipulation of tonal values through the use of filters. Backlighting accentuates (or produces) elements that can be used in composing the picture. Sidelighting in certain cases can produce the effects of both.

6

SIZE, SHAPE, AND CONTENT

FORMATS

When I speak about format I don't mean necessarily the size and shape of the negative (35mm, 18 × 24mm, subminiature, 2¼" × 2¼", 4" × 5"), but the size of the final print, which is independent of the original negative, and its shape, which is determined only by the content of the photograph or by the compositional means which have to be used to attain the most pleasing appearance.

The content of the photograph may determine the size of the camera used in advance. This choice, however, is important only to professional photographers who have to deliver a photograph of maximum quality in every respect, regardless of effort or expense. This does not mean that a 35mm camera cannot compete in a lot of situations with an 8" × 10" camera. I am sure that a 35mm camera can produce a better photograph in certain situations than the 8" × 10"—if the 8" × 10" could even do the job. The converse is valid also. Every picture situation and all picture contents have a most favorable camera format.

Most of the situations encountered by an amateur photographer can be solved very well, or even better, with ''amateur'' than with ''professional'' cameras. Since many professional photographers recognize the utility of smaller format cameras, they switch over to the use of these in situations which formerly required a larger format camera. I don't know whether it was a joke or not, but somebody told me that a wedding photographer once mounted a 35mm camera inside his 4" × 5", which was the symbol of his profession, and took such good photographs that everybody was amazed by them. He did this in order to avoid the prejudice of the people who might say, when they saw the 35mm camera, that they owned the same type of camera, and what kind of photographer used a small amateur camera at such an important event, instead of a big professional-looking one? Of course, these people apparently didn't know that everything depends on the man behind the camera.

The man and his experience, his knowledge, his taste, how he uses and selects his tools, and his available means of composition for emphasizing picture content are what matter.

I will deal now with the shape of the prints as a reflection of picture content, and as a means of composition.

The final shape of a print is determined in the darkroom, and generally we try to maintain the composition within the borders of the given paper format, say, 8" × 10". Since most amateur photographers use 35mm or 2¼" × 2¼" cameras, formats which are not proportionate to this size of paper, they are often involved in difficulties when they try to find the cropping that fits both the paper format and the composition of the picture. We have two simple and obvious ways to solve this problem: (1) We can take this difference between paper format and negative into account at the time of taking the picture; or (2) we can follow the format of the negative when enlarging without any consideration of the actual paper size.

Correcting in Shooting

If we try to maintain the full paper size we have to give up a certain part of the negative format. That means that we have to arrange the composition of the photograph accordingly. In the case of the 35mm format we use only 24 × 30mm out of the 24 × 36mm area. In other words, we eliminate about 1/6 of the area on the left or the right side in horizontal picture-taking situations, or the top or bottom of the image, seen in the viewfinder, when we take vertical photographs. Which area we neglect—the left or right, or the upper or lower—depends upon the position of the foreground and background. Since compositional lines start in the foreground, and figures are placed and emphasized in the foreground, it seems advantageous to keep that area of the film which contains the foreground (and/or the nearby objects) and to neglect the other.

The situation is similar with 2¼" × 2¼" (6 × 6cm) cameras, where we can use a negative area of only about 4.8 × 6cm. Since the ground glass of some twin-lens-reflex cameras is marked for 4 × 6cm size, or is divided into one square centimeter scales, it is easy to find out the necessary horizontal and vertical framing of the picture area. If the ground glass is plain, we may draw useful 4.8 × 6cm markings onto it.

Correcting in Printing

If we utilize the entire negative size to the very edges of the film, then we have to cut down about one inch from the shorter side of an 8" × 10" paper in long-format negatives and two inches from the longer side in square format negatives. The accent is on the word "if." It does not often happen that we use the entire surface of the film, even if we follow the shape of the negative format when composing the photograph. We can always set a small reserve space along the edges, for we never know how useful this slight reserve can be when we make our final decision about cropping during the procedure of enlarging.

A slight turning of the easel under the projected image may give an impact to the composition; sometimes we have to tilt the enlarging easel in order to correct distorted lines. In both these cases we can do the job more easily when we have this reserve, or perhaps we would not be able to do it at all without the extra space.

Some negative carriers cut slightly from the edges of the picture area, and we may be annoyed with a new enlarger if it does not allow us to reproduce carefully composed negatives right to the edges. A lot of manufacturers of single-lens reflex cameras took the necessity of this reserve into account, so we see in the finder slightly less than what is recorded on film.

Whether we use the entire negative area or not, our final decision about shape, cropping, turning, and tilting jells in the darkroom, where we may evaluate, on the easel, efforts we made at the time of taking the photograph. In this respect we are in an easier situation when using larger formats than 35mm, since larger formats do not require as great a degree of enlargement as the 35mm format to obtain the same print size. So at the time of exposure more stress has to be laid on finding the proper framing in the 35mm (or smaller) systems than in a larger system. Therefore, while maintaining a small reserve space around the edges, it is reasonable to take a few shots with different framings; we can select the best one later, during enlargement, or when we evaluate the contact sheet.

Backlighted situations require a dark and quiet background. This way, an attractive effect of plasticity comes into being.

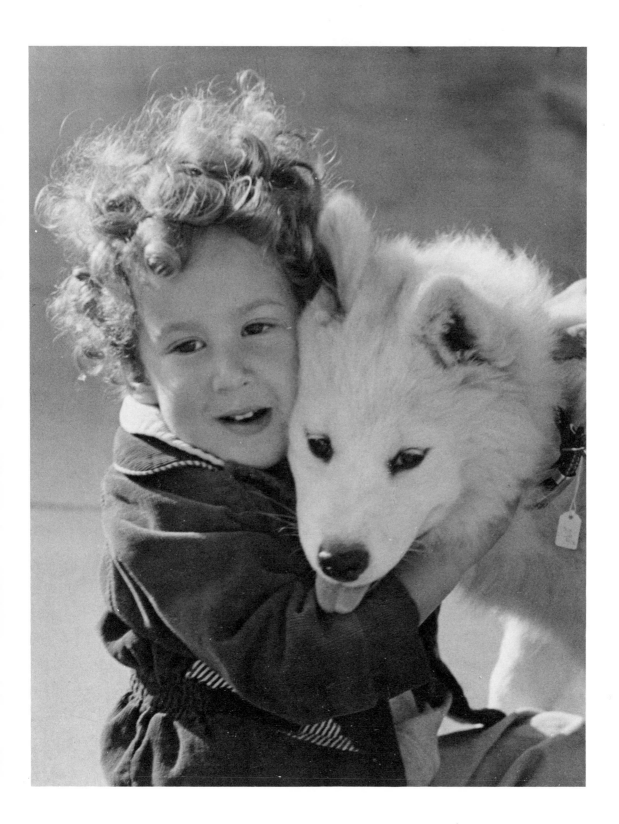

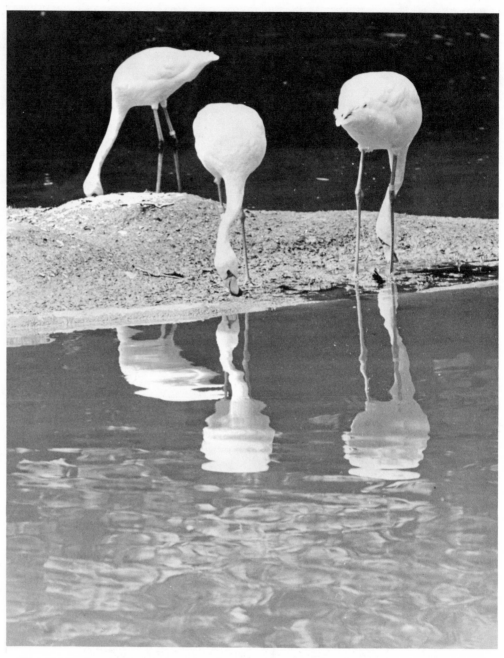

After high-contrast enlargement and proper cropping of the above picture, the emphasis is placed upon the intended area of interest (right).

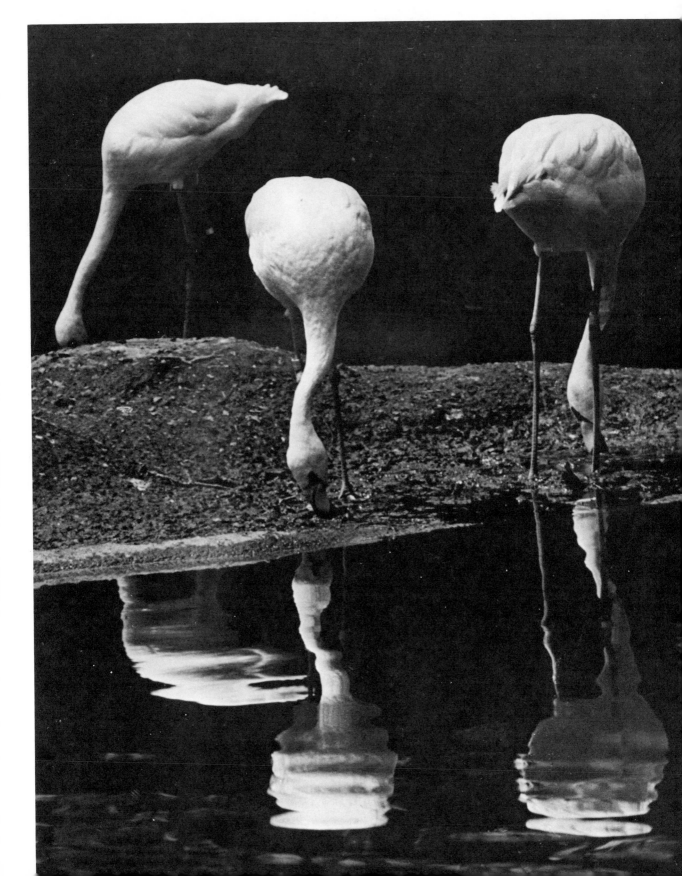

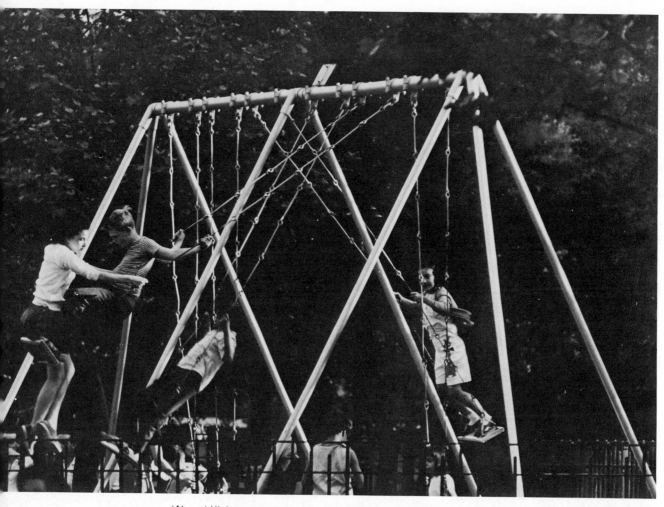

(Above) High-contrast enlargement emphasizes the compositional elements in this picture. (Right) The long, narrow format accents the excitement inherent in a group of arguing ballplayers.

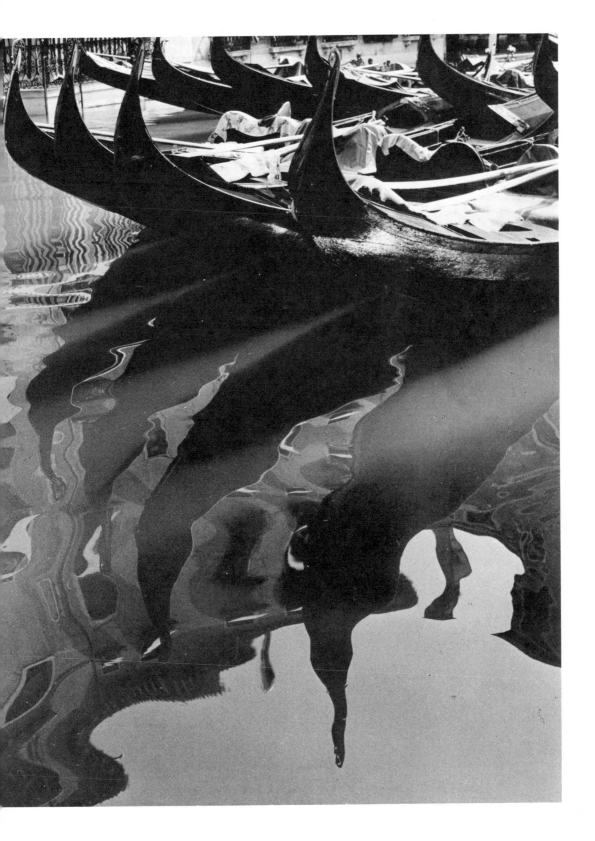

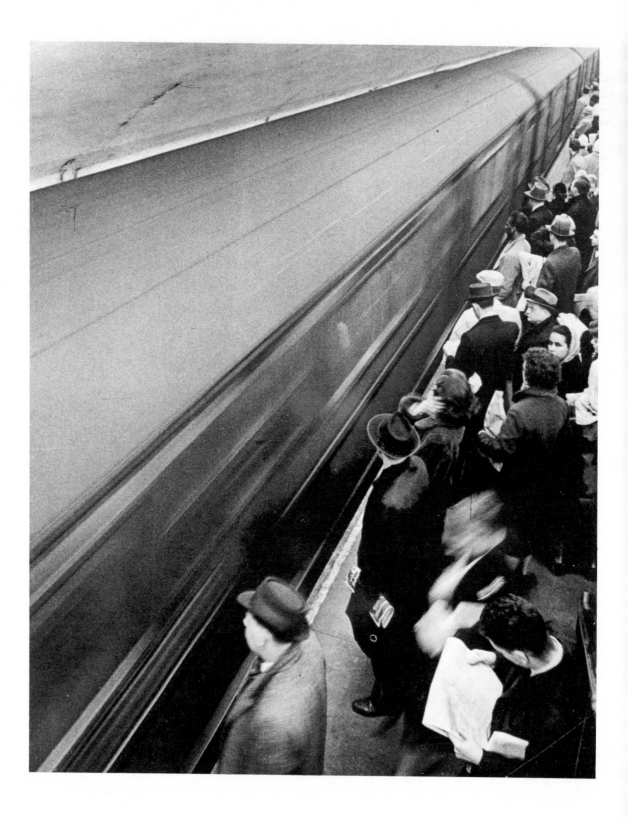

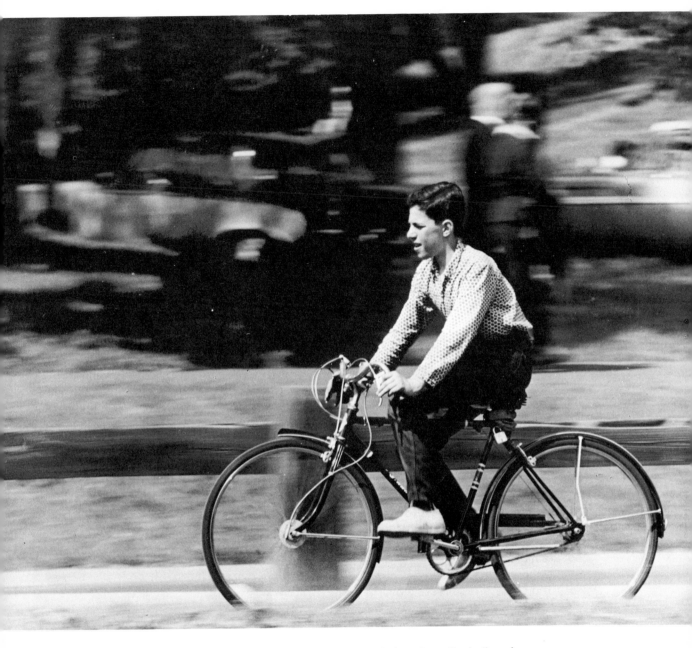

(Left) A strongly emphasized diagonal composition. The blur of the train introduces the feeling of speed. (Above) Relatively low shutter speed and panning introduce the feeling of motion.

Furthermore, I would like to draw it to your attention that blur does not *necessarily* emphasize motion. An over-all blur would produce an effect of plain unsharpness, which is, of course, unwanted. But partial blur, when parts of the moving subject appear sharp while other parts appear more or less blurred, gives the right effect. The situation is similar when more than one moving subject appears in the picture area (for example, cars) and some of them are pictured sharply, while others show blur. This is not paradoxical, since the speeds of the moving objects in the picture area differ (taking into account the relative appearance of speed due to the various distances from the camera), but the speed of the shutter is constant. In this way the shutter will stop movements which are slow enough for that particular shutter speed, but movements too rapid for the shutter speed will appear blurred.

The result is the same when some parts of the moving subject are closer to the camera than other parts, even if the speed is the same (for example, a train running in a diagonal direction toward the camera). The part of the subject closest to the camera will blur most heavily, and the blur decreases in direct ratio to the distance of the remaining parts of the subject, if the course of it is straight. Another possibility for recording a subject partially blurred and partially sharp is when the parts of the subject are moving in various directions in relation to the camera. Movement directed toward the camera requires a slower shutter speed than movement perpendicular to the shooting axis, in order to get an unblurred image on the film. Imagine a car running toward the camera on a rainy day, when puddles are on the pavement, splashing water all around. The direction of movement of the car requires a relatively slow shutter speed, but the movement of the water is perpendicular to the shooting axis; therefore, it will be recorded as a blur if we use the lowest shutter speed short enough to stop the movement of the car. In this way the speed of the car will be emphasized very effectively by showing a secondary effect caused by the movement.

Summing up: In order to achieve special effects, it is sometimes necessary not to stop movement in every photograph.

Balance

Although the rules of photographic-composition are used generally to maintain a certain constructional balance in the picture, this balance may be consciously neglected occasionally. The balance of the photograph is determined by the distribution of light and dark areas within the picture area, as we noted earlier. Since we know the rules we also know what will happen when we work against the rules. We know that a light area close to the edge of the picture will distract the eye of the viewer, whether it is connected with the content of the picture or not. For example: If we wish to emphasize the place where the picture was taken we can incorporate into the picture area a street sign or whatever else will indicate the location exactly. If this sign is placed somewhere in the inner area of the picture it is all right, because it does not excite too much attention in the midst of the more interesting picture content. But if

(Right) The slight blurring of the balloon and the boy's right hand emphasize action. Though the balloon and the boy are placed into the picture area in accordance with compositional rules, the picture would be better balanced if the smaller balloon were in front of the boy rather than behind him.

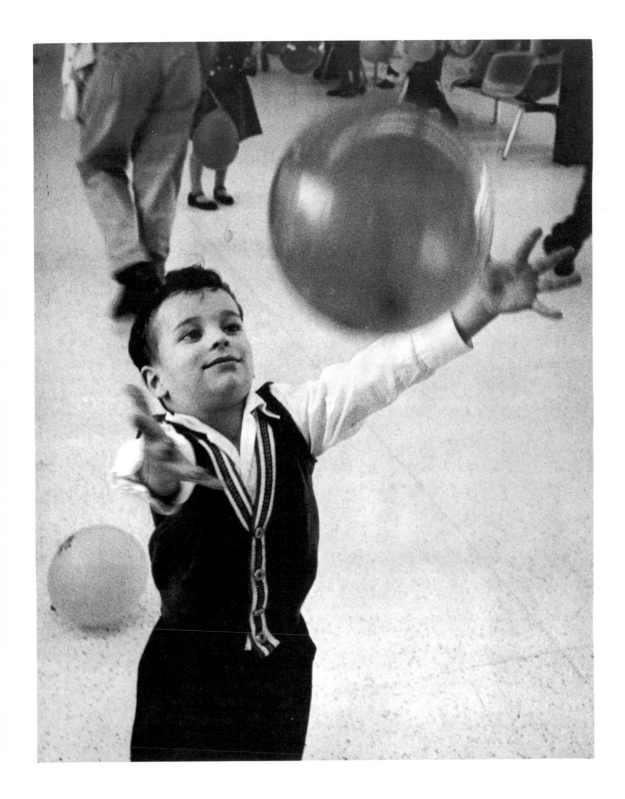

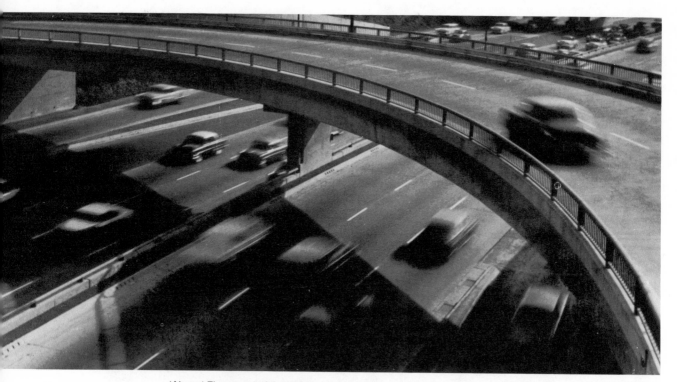

(Above) The speed of the cars is exaggerated by a slow shutter speed (1/15 sec.), and the narrow format and spun-out line effects support the theme of the picture: movement. Notice that the intersection of the two main lines is placed exactly in the Golden Mean point. (Right) This photograph presents a combined diagonal and triangular composition. However, the balance of the picture would be better if anything (a small boat or leaf) were floating on the water near the upper right corner.

the street sign is placed close to the edge of the picture (and, what is more, if it is magnified by the use of a wide-angle lens), it draws such attention that in the mind of the viewer the location becomes strongly emphasized.

If something is placed in a rectangular field, the most agreeable view for the human eye is to have the subject divided or positioned according to the Golden Mean rule. This view is so agreeable and quiet and it gives such a comfortable feeling to the viewer that it does not convey excitement. It does not arouse special interest, and sometimes it is just dull. Therefore, depending on the situation and the picture

content, we sometimes can disregard this rule, producing in this way more impact in our photograph. We can position the main situation or the main subject on the very edge of the picture area or close to one of the corners. This kind of construction gives an off-balance feeling, but since the balance is weighted in the direction of the picture content, the out-of-balance feeling creates tension. It gives a more definite accent. Obviously, this kind of manipulation is advantageous where movement, action, emotion, or excitement are emphasized. But when the picture shows a quiet subject, it is better to maintain the Golden Mean rule. Because no rule is without exception,

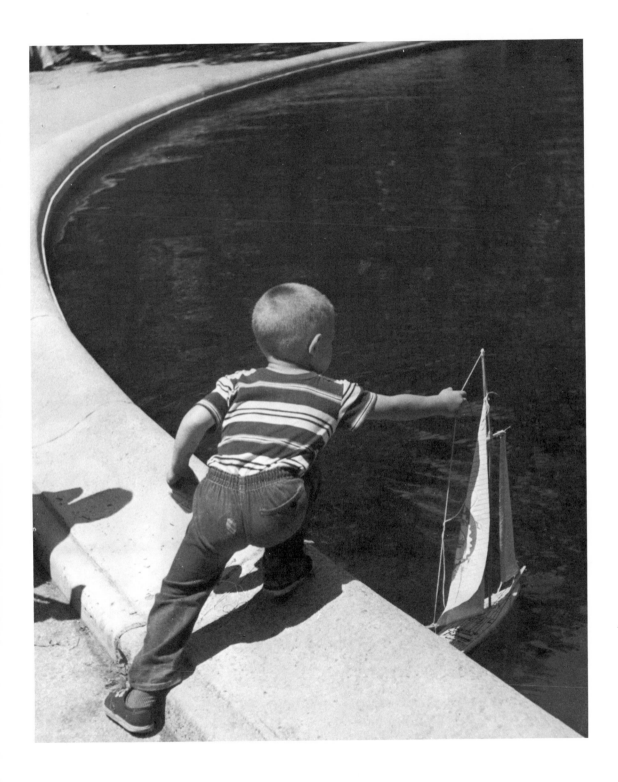

it is possible that we should maintain the rule in the first group of pictures and disregard it in the second group. This off-balance picture construction can be used together with the "cinemascope" effect (and obviously, in still photography, with the vertical extension of format).

Tonal Rendition

A change of tonal values, which shifts its appearance from the continuous gray scale into a graphic appearance—namely, to ink-drawing—does not belong strictly among the terms of photographic composition. But, since producing this effect requires effort on the part of the photographer, it belongs within the scope of this book.

One must first recognize the particular photographs suitable for this kind of treatment. The treatment, as you will see later, is merely technical, and actually every existing photograph may be treated by this means. When we search for this kind of picture in our file we should keep in mind that the most rewarding effect results when the photograph contains (1) a definite figure effect, (2) a pronounced line effect, (3) a pattern effect, (4) coherent areas with little or no change of tonal values within these areas, and (5) the silhouette effect.

The procedure is very simple. We duplicate the negative on a high-contrast positive film and develop it in a contrasty developer. Then, this positive is similarly reproduced. The process is continued until we get the final result, a negative with a complete lack of middle tones or any kind of transition from black to white. During the process, each reproduction becomes more contrasty than the preceding one.

Contour

Trying to rearrange the definite contours of the photograph is just the opposite way of achieving attraction. We may create this effect by implying a pattern-like structure in the print. This may be done by various means. The most simple of them is to take the photograph through a screen or through a patterned glass, placing the model close behind the glass or screen. So many photographs (good and bad) were taken in the past in this way, and published by magazines, that I consider them trite. However, experiment may produce a new wrinkle in the old technique.

We may achieve a pattern-like structure by use of grain and reticulation also. Reticulation is created when the temperature difference between processing solutions is too great, causing a tearing of the film emulsion in patterns similar to dried-out mud.

Despite common belief, grain structure is not easily achieved (at least for the purpose of pattern), since today's films, even the fastest ones, contain such a fine grain structure that it seems impossible to find a film-developer combination that will give satisfactory results for altering contours by coarse-grain effect. Even if we developed the film in a paper developer the graininess would not differ much from that produced by sloppy or careless processing. I suggest, then, that in addition to the use of a fast film-paper developer combination, and of course 35mm or smaller negative size, one should compose his picture so that the subject matter comprises only a small part of the negative area. In this way the great de-

(Right) It is not necessary for everything in a picture to be sharp. In this instance, the rotation of the wheels was emphasized by the slow shutter speed (1/8 sec.). The combination of circles represents a pleasant construction, and their diminution into the background produces a feeling of depth.

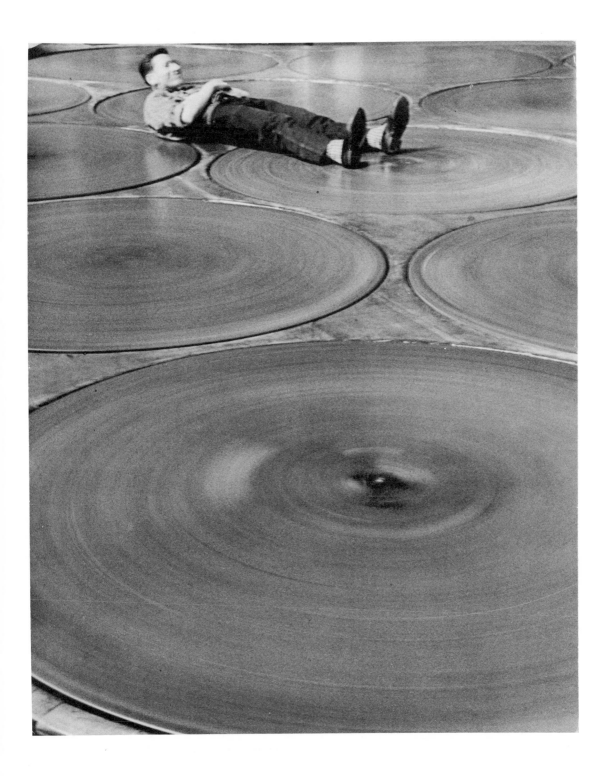

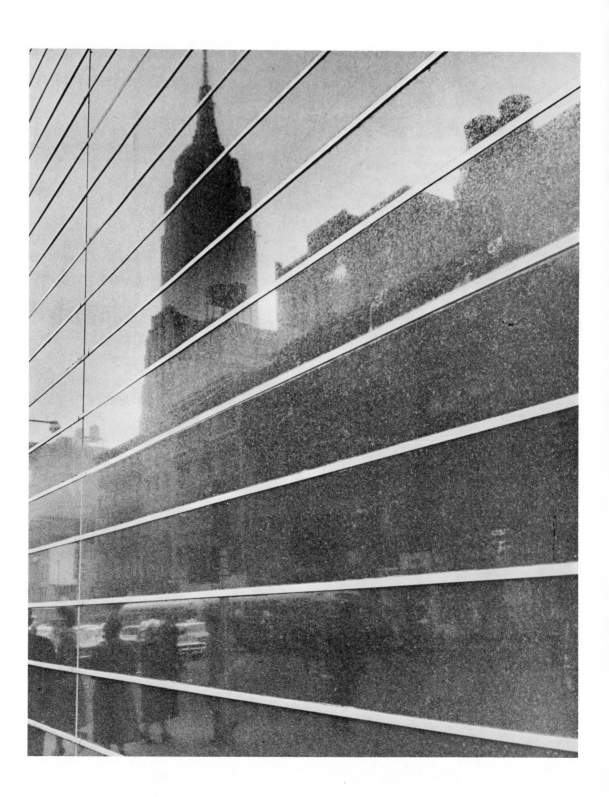

gree of enlargement may produce the required grain effect.

Unfortunately, when developing the film either for grain or reticulation effect, all the exposures on the roll are accorded the same treatment, ruining those pictures which the photographer would like to print normally. Because of this photographers often resort to techniques whereby the resolution of contours is achieved when printing. If we place a screen over the enlarging paper, and change the position of the screen after a certain exposure time, we may achieve this effect very easily. Various effects may be achieved by changing the density of the screen used, by repeating the procedure during the entire exposure time, and by varying the relationship of exposure times for the different positions of the screen.

PHOTOMONTAGE

Photomontage is not a means of photographic composition in the strictest sense, nor is it really breaking the rules. Still, I feel that it should be discussed among the irregular means of composition. In the creative art of photography it is frowned upon to use this means so that the imposed image appears as a natural element of the picture construction, if the same result may be achieved by regular means. For example, one must not replace the head of one person with that of another whose expression

(Left) An unusual view of the Empire State Building was achieved by photographing it as a mirror image via the black marble siding of an office building. Without the metal stripes in the black marble, the photograph would not have any compositional effect.

would match the situation better. On the other hand, clouds may be printed into an otherwise empty sky, without risking an accusation of forgery, though the montage is not obvious. What, then, is the difference between photomontage as a creative means and as forgery? Photomontage as a creative means can be used if it is obvious that the particular print *is* a photomontage, serving to create amusement, unusual effect, visualization of an idea, and the like. When it is not obvious, such things as formations or creatures may be placed into the picture area to serve only as compositional or decorative aids, or for any other kind of constructional purpose. So, the printing in of clouds may serve as a decorative element, or as balance in the construction. If we printed an airplane or some birds into the sky area this would also serve the balance of the construction. Printing in branches or some other kind of dark silhouette into the foreground can help to cover something which would otherwise be awkward for the construction of the picture, or it just may fill out an unnecessarily empty space.

Although several different types of photomontages and different techniques of application do exist, the situation and the photographer's purpose determine which type and/or technique has to be used. The main types of montage are: the multiple exposure, sandwiching negatives, printing in, and superimposing.

Multiple exposure is used when we wish to create a ghost effect, or when we wish to place something in a definite area of the picture. In both cases the exposures have to be taken before a black background (in certain cases only the secondary exposures require a black background). By varying the exposure times of the secondary exposures, we may achieve a more or less infiltrated image of the secondary subject, and thus determine the combined effect of the entire composition. Since no one can judge the effect of a photograph in advance, we have to take some shots with different expo-

sure times, and afterwards we can select one which fits our idea.

Another technique of multiple exposure is placing an alternative shade in front of the lens. Alternative shade means a window-like tool through which we take the exposures in such a way that the wings of the "window" are open and closed alternately during each exposure time. When using this tool a black background is not required, but we cannot achieve ghost-like or other superimposed effects.

Sandwiching negatives gives results similar to those obtained by multiple exposure, and it is used for the same purpose. Nevertheless it yields a greater variation of possibilities than the multiple exposure. The secondary negatives can be shaped easily to the requirements of the basic negative, by making copy negatives from them, and using all the available and necessary darkroom techniques to get the proper result. The most frequent use of sandwiching negatives is the printing-in of clouds, branches, airplanes, birds, into the empty sky. If we collected a lot of negatives for this purpose, we could select easily from our file the sort of clouds (or branches, or birds) that best fit the mood of the photograph, and sandwich them into the right area.

Printing one part of a picture into a definite area of another picture (by the regular enlarging procedure) is seldom-used and quite difficult procedure. A basic condition of this technique is that the image which is to be imposed must be darker than the area on which it has to be placed. For instance, you can print dark, heavy clouds into a white sky, but you cannot print white, fleecy clouds into a gray filtered sky.

Superimposing offers the widest variety of opportunities to bring the most unusual ideas into a picture. Besides the ethical rules, which I mentioned before, some technical rules have to be maintained also. The illumination (the angle of light) has to be the same in both pictures to be superimposed. Otherwise an unnatural effect may be created, unless, perhaps, the entire composition and picture content is meant to be unnatural and unusual. But however unusual the effect of such a photograph, it would not fit our goal if the viewer's attention is drawn away by such a small phenomenon as this: In one part of the picture the sun shines from the right side, and in another area of the photograph it shines from the left. Similarly, the perspective and the proportions of the superimposed parts have to match each other, in order to blend the superimposed part into the main part of the picture. Of course, it would be an exception if we were to make consciously exaggerated disproportions, as we would to show a funny idea, or anything else unusual.

As far as technical means are concerned, making a panoramic picture also belongs to photomontage, specifically, to the practice of superimposition. When we make the individual shots we have to make them in such a way that one part of the following shot overlaps the corresponding part of the previous one. While enlarging each part, we have to take the greatest care that the tonal qualities of the prints are exactly the same, especially in the sky areas. When cutting the prints we should follow some kind of close vertical contour in the picture area; for instance, the contours of a building, a tree, or whatever else. After cutting we have to make the edges of the prints as thin as possible by rubbing down the paper on the back side almost to the emulsion, using sandpaper for the procedure. Moreover, we should paint the thinned edges nearly the same tone as the print surface next to it, to avoid white cutting lines after the parts have been stuck together and the reproduction of the montage made.

Although these unusual and rule-breaking techniques are not too often used, it is good to keep them in mind, in order to widen our photographic sight and our communications ability, and perhaps to gain inspiration in certain situations.

7

COLOR COMPOSITION

Photographers have a much easier job achieving pleasing results in color photography than in black-and-white, since the colors of the objects around us do not have to be translated into the gray scale of black-and-white photography. The situation is really this: If we would like to achieve higher recognition in color photography than as mere snapshooters, we have to take into account a lot of rules, just as in black-and-white photography we had to learn many rules in addition to the simple knowledge of how to transform colors into the gray scale of black-and-white film.

Many of the rules and hints of black-and-white photography (the means of composition and construction) apply to color photography. So, when taking color photographs, keep in mind those compositional rules and means you learned in the previous chapters. However, though we can forget about transforming colors into the gray scale, we have to take into account a lot of special effects in connection with the difference between the vision of the human eye and the rendition of color film, just as we did in the case of black-and-white photography. For the sake of a proper and forthright examination, I will start with a short presentation of color theory and with an explanation and examination of color psychology.

COLOR THEORY

The colors of objects in nature depend on what parts of the spectrum they reflect. The colors of the visible spectrum extend from violet, which has a wavelength of 400 nanometers, to dark red, which has a wavelength of about 770 nanometers. The mixture of all the wavelengths of (colored) light results in colorless (white) light. By using a prism we can break up this colorless light and display its ingredients again. Objects in nature receive a primarily colorless illumination. If an object reflects the colorless illumination in the same proportion as it receives it, it appears colorless. If a colorless (proportionately reflecting) object reflects a great part of the light received, it appears white. Objects gradually become darker and darker as the amount of reflected light decreases, and an object becomes completely black if it absorbs all the light received.

If the object absorbs most of the light received, but reflects only a certain wavelength, it appears in the color determined by that wavelength. If the object reflects mainly one kind of wavelength but also reflects a certain part of other wavelengths, its color loses saturation and becomes mixed with white or black, depending upon the amount of proportionate reflection. If the reflection is not proportionate the basic color of the object becomes mixed with some other colors.

Although natural white light is a mixture of all the colored light rays, and objects in nature reflect the individual colors in a wide variety of combinations, it is not required to mix all the colors to create a colorless light. Three primary colors are essential to this: blue, green, and red. In the foregoing and

in the following I deal in terms of the so-called *additive mixing of colors.* That means the mixing of colored light rays. In recognizing the ingredients and means of composition in color photography this knowledge is desirable. The other color system, the *subtractive mixing of colors* (which we use when we mix dyes), plays its role in the chemical execution of color photography, and I will not deal with it.

Going back to the three primary colors, it is obvious that if we are able to produce white light by mixing these three colors, we can produce all the colors of nature by appropriate mixing of the colors or only two of them. If we mix two colors we get a third color. If we mix this color with the color that is missing from the mixture we get white again. Therefore, a color which, when it is mixed with another color, produces white is called a *complementary color.* The following diagram presents the color circle in which the colors in the nodes of the triangles produce white when they are mixed. Since a color between two others is a mixture of them, the opposing color is always the complementary color of that mixture, being in the opposite node of the triangle. Colors next to each other in the circle are called *adjacent.*

Now we know of the existence of complementary and adjacent colors, and we know how they are determined. Let us see how they fit into the psychology of vision and comprehension. It is presumed that the relationship between these colors (for instance, the complementary color is always the color missing from the mixture that will produce white) has to do with the psychological nature of our vision.

Refer to the diagram in Chapter 1 that demonstrated the different appearance of the same tonal value placed into various surroundings. Draw two such figures (a circle in a rectangle). Leave the circles white and paint one of the rectangles red and the other green. If you stare a little while at the drawing, the circle in the red square seems to be a light green, while the circle in the

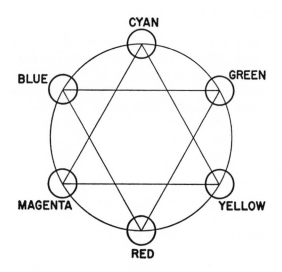

Diagram 10. *Colors opposite each other on the color circle are complementary. Colors in the nodes of the triangles produce colorless light when mixed, as do complementary colors.*

green field appears light red. This phenomenon proves that if complementary colors are close to each other in the same field the contrast between them is exaggerated, since color was produced in the white circle merely by illusion due to another color. For example, red flowers in a green meadow seem to be more red than they really are. On the other hand, the effect of adjacent colors is more harmonic. So I can state that both combinations of color can improve the effect of a color photograph if applied wisely, or destroy it if applied wrongly. From the color circle we may find color compositions which can be used for either contrast effect or for harmonizing effect. These are the bases of color theory, and in the following I will often refer to them.

Besides basic color theory, the human faculty of seeing colors (or not seeing them) plays an important role in color composition, and all the phenomena joined to this faculty can be labeled as color psychology.

COLOR PSYCHOLOGY

How the human eye perceives light is not related closely to the substance of this section. I do not want to discuss it in detail. But I would like to emphasize that the light falling on the retina of the eye is accepted by two kinds of nerve terminals. One kind accepts strong light and transforms the different wavelengths of the light into color perception. When the intensity of the light decreases to a certain level it can no longer excite these terminals. Therefore, the other kind of nerve terminal comes into action. The trouble is that these second terminals are color-blind, so in dim light we cannot see colors. Therefore, we are interested only in the work of our "daylight" terminals.

Although the red-, blue- and green-sensitive terminals are distributed proportionately on the retina of the eye, our brain does not accept the color rendition those terminals report to it. It sometimes transforms this rendition into other colors. The brain does this, mainly, to compensate when the color of the illumination changes, and produces a sense of colorless illumination when in reality this illumination is red or blue. But film cannot accommodate itself to these mental color corrections of illumination and it records the illumination exactly as it is. When I speak about the change of the color of the illumination I refer principally to the limits of daylight and artificial light. Although many kinds of tools are available to adjust the film to the kind of illumination (daylight type or tungsten type films, conversion and color-correction filters) and these tools are really very helpful, we can apply them only when we recognize the situation. Since our ability to make accommodations destroys our ability to recognize colors exactly, we have to learn everything that has to be taken into account. We have to judge all the circumstances which may influence the color rendition of a particular area, and which may be different from our comprehension. We may be aided by a color-temperature meter, but sometimes even this meter cannot give an answer to the proper color rendition of a particular area, but only for the total.

The difference occurring most often between color rendition and color comprehension is the discoloration of shadow areas because of reflected light. In the great majority of cases we have trouble with blue light reflected by the cloudless blue sky into the shadow areas. We can overcome this blue cast by using a color-correction filter. The strength of the filter depends upon the saturation of the blue sky. We can judge the saturation using as a basis the fact that when clouds are present in the sky they reflect colorless light, so no filter is needed.

Another kind of reflection occurs when colored surfaces are present near the subject (walls, fences, clothing, and the like). When these surfaces are incorporated within the picture area the effect is quite natural, but when they are outside the picture area our eye apprehends the reflection as a strange effect in the picture. In nature we see the subject together with its surroundings and with the reflecting surface, so the reflection does not arouse too much interest. But it does so when we see the subject without the surroundings in the film frame. Therefore, when taking color shots beware of possible reflections and look around.

Of course, this effect of reflections can be used consciously as an element of the picture's color composition, and it is good to be aware of its existence. We can overcome blue shadows if we use a gold-reflecting surface instead of the regular silver device to fill in light in daylight. Speedlight or blue flash bulb can be used very efficiently for this purpose also, since their color temperature is close to that of the average daylight, but we have to take care not to overdo this kind of filling-in with light.

When colored light predominates—either blue, when the sky is cloudless; or red, when the sun goes down or rises; or in tungsten light conditions—we cannot compare the effect of the total illumination to

anything else, so the transforming action of our brain can fool us very easily. But this compensating action cannot work when we look at color pictures or slides, because we can compare the colors of the pictures with the colors of our environment or with the previous transparency projected, say the tint of one person with the tint of another person, or with the color of our own hand. This comparison function works also when during projection a blue transparency follows a yellow one. The bluish cast in this case would be very conspicuous, since our comparative sense is ready to exaggerate the contrast of complementary colors. In this way each shift in the color rendition will be recognizable in color photography.

Conclusion: Because we cannot make comparisons we do not recognize the changed color of illumination, and we accommodate ourselves to it when we take pictures; but we recognize it, sometimes in an exaggerated manner, when a means of comparison is provided as we look at the pictures.

Both color theory and color psychology have to be taken into account when we try to evaluate the possible effect of our color photographs, availing ourselves of those means offered by regular photographic composition and by the added possibilities of color composition.

SPECIAL MEANS OF COLOR COMPOSITION

As in black-and-white photography a disturbing effect is created when tonal qualities are distributed without any apparent system. The construction of a color photograph also requires a system, both in the meaning of regular composition and in the distribution of colors. A colorful picture cannot always claim recognition as a work of art. Not everyone claims recognition as an artist, but almost everybody wants recognition of his color photograph rather as a good picture than a jumbled picture.

So as the first step toward a well-composed color photograph we have to avoid the topsy-turvy distribution of colors. Such a topsy-turvy picture is labeled "leopard-skin." It is obviously more advantageous to work with large areas of color than with small spots, even if some system could be recognized in the distribution of those small areas. The exception is when we consciously hunt for special or unusual effects, or an abstraction.

As the second step, we can apply all the rules of black-and-white photography (figure effect, line effect, depth effect, light effect, background-foreground relationship, perspective gimmicks, and so on) in the field of color photography as well, but together with an understanding of the effect of colors, using them combined with these effects.

As a basic approach toward understanding colors, we divide them into two groups: *warm* colors (red, orange, yellow and the transitions from one to the other) and *cold* colors (violet, blue, green and the transitions). Within these two groups we can evaluate colors according to their *saturation*. Saturation means the degree of clarity (purity) in comparison with the pure colors of the spectrum. The saturated light colors are necessarily brighter than the others mixed with black, gray, white, or with some other color, and are, of course, brighter than the saturated dark colors. And when the subjective dark-light value is equal, the color of the warm family is always brighter.

In black-and-white photography the light and bright tonal values attract the eyes of the viewer first. So, in color photography the warm colors are the most conspicuous. The brightness of a color—beyond its inherent brightness-rank—also depends on the color of its surroundings, according to the psychology of complementary colors. This is the most important contrast effect in color photography after the light-dark effect borrowed from black-and-white photography. All the effects obtained in black-and-white photography by applying the dark-light relationship can be transformed

to color photography by the application of the warm-cold relationship.

In addition, warm colors are accepted as approaching colors, while cold colors are departing colors due to their psychological effect. This approaching-departing effect of the colors can be used very efficiently as a means of depth composition. Similarly, the attractive effect of a bright spot of warm color in cold surroundings plays the same role in color photography as the highlight in dark surroundings in black-and-white. So I can continue the comparison with the idea of balance, which depends on the distribution of light and dark areas in black-and-white. This is true in color also, taking into account the previously discussed color theory and especially the contrasting effect of complementary colors.

If we translate the ideas of color into the language of black-and-white photography we realize that the rules and effects are basically identical. Remember, color is our basic comprehension, and the gray scale is a secondary product of translating colors into black and white, according to effects we experience in nature. In Chapter 5 we had to use filters to separate a sunburned face from the dark-blue sky to get a contrast of tonal rendition in black-and-white. In color, we obtain the effect without filters due to the strong contrast between orange-brown and blue.

Although most of the effects and rules are identical, the translation back to color causes some effects to come out in a quite different way. The depth of field relationship and the sharpness conditions both in the background and in the foreground play different roles in black-and-white from those they play in color. Therefore, they have to be treated according to this difference. Since the ideas of depth of field and sharpness are close relatives I can deal with them together.

Admittedly, unsharpness in the background (or outside the depth of field) can produce an illusion of depth, and can emphasize subjects lying in the sharp zone,

either in a black-and-white or a color photograph. However, in color photography we can apply this means only within limitations. In black-and-white photography we can afford certain deviations in presentation from our normal comprehension. What is more, sometimes we must make deviations in order to render in the photograph the illusion we got from our normal comprehension. In color photography we cannot afford too many deviations in sharpness, because the evaluation of a color photograph in our mind has to match the comprehension we got in reality. Therefore, this out-of-focus effect can be used when coherent areas of the same or adjacent colors are present in the out-of-focus area. When smaller areas of different colors are present it is less disturbing if these are sharp. Anyway, the subject won't blend into the background due to the color difference, which is missing in black-and-white photography. Therefore, we don't have to use this out-of-focus effect to separate subject and surroundings and/or background.

Generally, keeping the composition as simple as possible is good advice in color photography also. This explains why color photographs which contain few colors (adjacent colors in the great majority) on great coherent areas and only small spots of complementary colors (or none at all) are so tasteful and attractive. Watch this kind of color composition in films by most of the modern movie directors.

An interesting and attractive variation of such simple composition occurs when great colorless (gray, white, and black) areas occur in a picture and small color spots are all that indicate it is a color picture. Backlighted photographs may give an illusion of this kind of "colorless" color picture, though the dark areas of the picture may be brown, green, or blue instead of gray or black.

As in black-and-white photography, bright lighting is very attractive and causes sparkling colors in the well-illuminated (highlight) areas, especially if translucent

objects are present (balloons, colored glass, leaves, clothing, and so forth). Exposure has to be calculated for favorable rendition of the highlight colors.

When the direction of light is changed in color photography we are unable to control shadow and highlight rendition through dodging or burning-in (except in negative-positive home processing), so we rely upon the inherent latitude of film. Although this latitude has been improved in the past few years, we still have to take into account the fact that color film is only able to surmount brightness differences (while maintaining a correct color rendition) in a ratio of about 1 to 6. This ratio means 2½ f/stops, and this narrow limit is often not enough for correct color rendition in back- or sidelighted situations. So, if we are unable to fill-in with light we have to determine the importance of different areas and select the exposure which fits this determination. We have to take into account also that colors appear in their full value when the object receives direct illumination. So in sidelighted situations the colors of the illuminated side are much more saturated than the colors on the darker side even if the latitude of the illumination is within the 2½ f/stop limit.

We have almost no exposure problem when the subject is frontlighted. The only circumstance which has to be taken into account is the light-dark value of colors. When light colors are dominant we *decrease* the exposure by one-half to one f/stop. In the case of overwhelming majority of dark colors we have to *increase* the exposure by one-half to one f/stop.

Distant shots (especially by telephoto lens) require in general one-half to one f/stop shorter exposure than is indicated by the meter reading because of the lightening effect of aerial haze. Although we gain contrast in distant shots by shortening exposure time, this does not overcome the bluish cast of aerial haze. This bluish cast is not disturbing when a normal or wide-angle lens is used, since aerial haze belongs to the landscape according to our comprehension also. But our usual perception shows a wide-angle rather than a telephoto effect. Do not confuse our usual perceptive characteristics with the perspective rendition and angle of view of our eye, which corresponds to about a 100mm focal length lens for the 35mm negative format. It gives quite a strange impression when we look at a color photograph that shows only a small segment of our normal area of perception but a full measure of bluish cast belonging to that segment. A haze filter does not always help, so when aerial haze is too strong, forget about telephoto shots.

MIXED LIGHT

In general, it is not recommended that you take color photographs in mixed light conditions; i.e., when both daylight and artificial illumination are present in the picture area, since each type of film is sensitized only for one kind of illumination. When the appropriate illumination is not used, severe shifts of color rendition occur. When tungsten film is used under daylight conditions, the color rendition is shifted toward blue, and when daylight film is used under incandescent light conditions, the rendition is shifted toward red.

However, we can make use of this imperfection of our material for compositional purposes, gaining interesting and unusual effects. Two kinds of application may be made: (1) When the type of film required by the primary illumination is used and only small spots or areas are illuminated by the other kind of light; and (2) when larger coherent areas are incorporated into the picture area, but each area is illuminated by a light source of different color temperature. In the latter case we have to try to imagine and estimate the final effect of the use of either kind of film. Or, we may take the shots with both tungsten and daylight film and evaluate the results afterward. It seems to be advantageous if the off-color-balance area is smaller than the correct one. For example, if we take a shot on daylight film

through a door from a daylighted room to another room in tungsten illumination, it seems to be more advantageous if the picture is framed so that a greater part of the daylighted room is shown in the picture. A small part of the other room would then serve as an unusual effect-producing element (a strong yellow surface beside or inside a normal surrounding). If our camera is loaded with tungsten film, the other room will be rendered as normal, but the door of the daylighted room may serve as a strong blue frame for the entire composition. This is only one example to illustrate the possibilities, and I am sure that one's own inventiveness can find innumerable possibilities for this kind of (basically incorrect) color rendition.

To simplify the estimation of the result to be expected, the following table shows the color temperature of various light sources in approximate Kelvin grades.

Average daylight illumination	5000-6000 K
Blue sky	12000-16000 K
Overcast sky	6000-8000 K
Blue sky around sunset or sunrise	12000-27000 K
Electronic flash	5000-6500 K
Daylight from 2 hours after sunrise to 2 hours before sunset	4000-5000 K
Clear flashbulbs	3400-3800 K
Blue flashbulbs	5000-6000 K
Photoflood lamps	3200-3400 K
100-watt incandescent bulb	2700-2800 K

The sensitivity of daylight color reversal film is about 5500-6000 K (varies with make) and that of tungsten film is about 3200-3400 K. We may use each type by using color-conversion filters. To cut excess blue and ultraviolet radiation color-correction or haze filters are recommended.

INDEX